CHARLTON ATHLETIC

A PICTORIAL HISTORY

DAVID C. RAMZAN

AMBERLEY

First published 2013

Amberley Publishing
The Hill, Stroud
Gloucestershire, GL5 4EP

www.amberleybooks.com

British Library Cataloguing in Publication Data.
A catalogue record for this book is available from the British Library.

ISBN 978 1 4456 1724 4 (print)
ISBN 978 1 4456 1736 7 (ebook)

Typeset in 10pt on 12pt Sabon.
Typesetting and Origination by Amberley Publishing.
Printed in the UK.

CONTENTS

ACKNOWLEDGEMENTS

I wish to express my most sincere gratitude and appreciation to Charlton Athletic statistician Colin Cameron, who first introduced me to book publishing almost twenty years ago when we were both involved with the Charlton Athletic Heritage Committee. Without his help, guidance and advice, the production of this book would not have been possible. Sadly, as anyone associated with Charlton Athletic will know, Colin Cameron passed away suddenly just before Christmas 2012; it was a great loss to the club and everyone who knew him.

The assorted memorabilia and images produced within this publication, gathered together over many, many years, come from my own collection, from the collections of family, friends, supporters, players past and present, and members of the football club, including:

Colin Cameron, John Rooke (Former CAFC Staff Member – CA Former Players Association Committee), Committee Members of CA Former Players Association, Mark Baines, Sue Copus, Sarah Ellis, John Hutley, Luciano Masiello and Graham Sadler, Tony Farrell (CA Disabled Supporters Association), Tom Morris and Steve Bridge (former club photographers), Tony Mitchell (photographer), Jim Jelf, Arthur Jensen, Mick Berry, Percy Castle, John Chadwick, Keith Ferris, Harry Field, Eddie Goatman, Andy Grierson, Paddy Hawkins, Ernie Hurford, Harold Lugs, Eric Keep, Ken Little, Bob Nokes, Charlie Revell, John Roth, Ken Starkey, Archie Star, Peter Barrett, Bill Swingler, Harry Trew, Dennis Butcher, Frank Beech, Don Freeman, George Daily, Christine Lawrie, Peter Dutton, Gladys Dutton, Jean Tindell, Dot Blackwell, Eddie Marsh, B. N. Poulter, Dorothy Barrom, Betty Read, Dot Blackwell, Andrew Hawkins, Ron Weston, Lester Trask, Iris Hemmings, John Wimbury, Jim Walker, Lee Poynter (Bugle Horn-Charlton), Geoff Billingsley, Andrew Billingsley, Norman Billingsley, Dave Headley, Steve McHattie, Alan Armstrong, Gerry McCarthy, Stuart Jeffries, Colin Barker, Fred Clarkson, Graham Clark, Alan Russell, the Greenwich Heritage Centre, Charlton Athletic FC – Peter Varney, Roy King, Rick Everitt, Mick Everett, the CA Supporters Trust, the *Mercury* newspaper series, the *Mail on Sunday*, the Newspaper Licensing Agency.

My thanks also go to the following players, who in the past have provided images for use in my publications: Eddie Marsh, Peter Croker, Charlie Revell and Bobby Ayre.

BIBLIOGRAPHY

Particular mention must be made in reference to:

The Valiant 500
Home and Away with Charlton Athletic, Colin Cameron
The History of Charlton Athletic
Valley of Tears, Print Co-ordinations, Richard Redden
The Football Grounds of England and Wales, Simon Inglis (Willow Books/Williams Collins PLC)
Charlton Athletic, Anthony Bristowe (Convoy Publications)
The Jimmy Seed Story, Jimmy Seed (Sportsman Books)

If for any reason I have not accredited any material used in this publication to people or organisations where necessary, or I have failed to trace copyright holders as required, then I should like to apologise for any such oversight.

AN AFTERNOON KICK-OFF

As I ran down the front steps of the Granada cinema, Greenwich, in January 1966, after watching the latest instalment of *Zorro's Fighting Legion*, I little realised that later that day I would be on my way to watch a live football match for the very first time, and the players running out on the pitch would soon become my legion of football heroes. Just like Zorro, who faced a series of perilous situations at the end of each episode, crushed under a rockfall or blown up in a mine, only to make an improbable escape in the next instalment, my legion of football heroes would also be faced with their own series of dramatic adventures throughout the seasons I have supported Charlton Athletic Football Club.

On my return home after the pictures, we sat in the kitchen while my mum made lunch and tried to come up with some ideas of what we could get up to for the rest of the day: we could play football in Greenwich Park, go along to the Thames and muck about on the river, visit the National Maritime Museum, or clamber about the old clipper ship *Cutty Sark* … all things we had done before. My mum then suggested going to a football match.

I had never been to watch a game of football before, and although a lot of my older family members and their friends had at one time been Charlton Athletic supporters, I had never thought much about going to watch them play. Some of my school friends had been to The Valley, Charlton's home ground, which was just a few miles along the road from where we lived; one even had a replica Charlton kit that he wore for games lessons. However, most of my schoolmates at the time had kits of top clubs like Arsenal, Chelsea and Liverpool – teams they said they supported, although none had ever been to watch them play. I had a Wolverhampton Wanderers kit – not because I supported them, I just liked the colours. Later, my uncle and aunt gave me a West Ham United kit as a birthday present, which I chose because they had recently won the FA Cup, and they had some great players in the team – Bobby Moore, Johnny Byrne, Martin Peters and Geoff Hurst who, everyone should know, went on to score a hat-trick for England in the 1966 World Cup final at Wembley. And yes, the ball did cross the line, I saw it clearly, live on black-and-white television!

However, before this historic event took place, my loyalty to Charlton Athletic FC finally began on that Saturday afternoon, when my mum gave me 6s (30p in today's money) to share with my friend, so we could go to watch a match at The Valley. After jumping off a bus at Charlton, we crossed over Woolwich Road to walk down Ransom

Road and through the railway arches out onto Floyd Road. The carnival atmosphere we came upon was incredible; especially as our only experience of watching football came through match highlights shown on television. There were hundreds of Charlton Athletic supporters heading for the club's large red-and-white main gates, and down towards the turnstiles opposite the main grandstand. Some were wearing red-and-white knitted hats, others wore red-and-white scarves and large rosettes, while a few of the more lively fans were twirling large wooden football rattles around their heads, singing football songs and chanting the club's name.

My friend and I joined in with a crowd of supporters filing through the main gates, heading towards the turnstiles, to take our place in a queue, ready to pay our 2s entrance fee.

The Valley, once reputed to be the largest football club ground in Britain, was now a ramshackle place (which I did not notice at the time) and had not changed that much since Charlton had played First Division football there in the 1930s. The ground, shaped in the form of a large bowl, had a main grandstand situated along the west side of the pitch; a long, low, covered standing area behind the goal to the north; and a high uncovered area of concrete terracing behind the goal at the south end. The most amazing feature of The Valley was the huge, steep East Terrace, which seemed to reach up to the sky.

After buying a burger cooked in boiled water and served up with lukewarm stewed onions in a dry bun – the great football cuisine of its day – we followed along with other supporters making for the southern terrace to take up our position behind the goal. When the Charlton players came out onto the pitch, I was expecting to see them wearing the traditional kit of red shirts and white shorts. However, on that day the players wore a kit of all white with red shoulder flashes on their shirts. As the players ran over towards the goal where we were standing, a strong medicinal aroma wafted towards us, which I later discovered came from liniment players used as a muscle embrocation. Although my memories of the actual match that day are vague, the smell of White Horse Oils always reminds me of the day when I went to watch a Charlton Athletic match at The Valley for the very first time.

Throughout the years I supported my club I also attempted to play a bit of football, although any footballing skills I actually possessed took me no further than playing in the goalkeeper position at school and for a few local clubs in Greenwich. Then, at a training session one day, while attempting to make a spectacular diving save, I tore the ligaments in my left knee, which ended any hopes I had of making football a career (an unlikely and highly improbable future occupation in any case, damaged knee or not). After relocating to take up a working opportunity in Kent, I attempted to play some football as an outfield player with Canterbury City FC for a couple of seasons, which went no further than training and playing with the reserves.

Much later on I then began coaching football, after my eldest son, who was about seven years old at the time and a Charlton supporter like his dad, wanted to join a local football club. Because of his visual impairment none of the local clubs could take him on, as they did not have any coaches who were experienced in working with children who had disabilities. Around the same time, Charlton Athletic had just started to run their children's disability football programme, which I took my son to on Saturday mornings before we went off

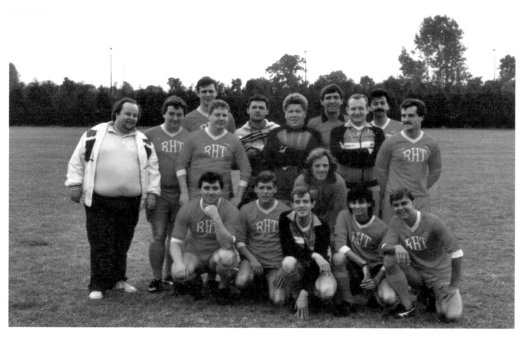

Greenwich Victoria Veterans Team, with author David Ramzan in the back row, second left, before a charity match played in aid of Maze Hill Special Needs School in the mid-1980s.

Opponents, The Queen Victoria (public house) Greenwich. The match was drawn 0-0, with the match winners' prize of a barrel of beer shared between both teams.

Charlton Athletic community coaches, author David Ramzan back row far right, with 1966 World Cup hat-trick hero Sir Geoff Hurst, during a visit to a children's football tournament, the Congo Cup, at Port Lympne Kent, May 2008.

to watch Charlton play in the afternoon. My son played in one of Charlton's first visual impairment teams, and it was the club's disability football programme that set me on my way to disability football coaching. Once I had taken my FA coaching qualifications, we started up a children's disability football club in Kent, which we named Invicta Valiants. I then joined Charlton Athletic as a football coach in the club's award-winning community programme, working with disadvantaged and socially excluded youngsters in the football coaching activities and crime reduction initiatives. Through coaching, I had the privilege of meeting my 1966 World Cup hat-trick hero Sir Geoff Hurst, when he came to Kent to take a look at the Charlton Athletic community work in progress, and later when he made an appearance at one of the Kent FA's Pan-Disability football tournaments.

Since attending that very first match at The Valley, six months before Geoff Hurst scored his three goals against West Germany in the 1966 World Cup final, Charlton Athletic FC has progressed beyond all expectations. I remember a day during the 1970s, when Charlton were languishing in the third tier of the Football League, when my friends and I were playing bar-billiards and having a couple of beers in the Prince of Orange at Greenwich, before setting off for The Valley. I told them that I doubted any of us would ever live long enough to see Charlton play in the top division of the Football League. Unsurprisingly, my friends all agreed ... How wrong we would all be.

FOUNDATIONS BUILT ON A SOUTH-EAST LONDON MEADOW

The FA Challenge Cup final, watched by millions of football fans from countries all around the globe, is considered the greatest domestic cup competition of all time, won by only the very best teams playing in the English Football League. At the end of each football season back in the 1960s, my friends and I would all be sitting in front of our television sets on cup final day, ready and waiting for the football festivities to begin. Shown live on BBC's Grandstand, the morning's build-up to the final included interviews with special guests, celebrity supporters and past players, reminiscing about previous cup finals and supporting or playing for one or other of the cup finalists appearing at Wembley that day. If my dad was not working on cup final day, he would usually watch the early part of the broadcast with me before he popped across the road to spend the afternoon in his local, the Crown on Trafalgar Road, Greenwich. On one of those cup-final days, when Manchester United were playing Leicester City, he casually mentioned that when he was a youngster he went with a coach party from the Crown to watch cup-holders Charlton Athletic play Manchester United in the fifth round of the cup. Little old Charlton ... FA Cup winners ... that was news to me.

When my dad first told me about his FA Cup trip, Charlton had only escaped relegation to the Third Division on goal average, and I could not believe that a team like Charlton would ever have been good enough to have won a trophy as famous as the FA Cup. My dad then told me about the days when Charlton Athletic played First Division football at The Valley in front of over 70,000 fans, and played in cup finals at Wembley too.

The illustrious history of Charlton Athletic first began in June 1905, almost fifty years before I was born, when a group of young boys living in North Charlton decided to form a football club named Charlton Athletic, which was one of several football teams in the area at that time using the name Charlton in the club title. The difference was that this new club would one day become winners of the FA Cup.

The boys who first wore the red shirts of Charlton Athletic played home matches at Siemens Meadow, a patch of rough ground near the Thames, opposite the back gardens of a row of terraced houses on Hardens Manorway. The first recorded match played on the meadow came against Silvertown Wesley in December 1905, with Charlton winning 6-1. Before the start of the following season, the boys from Charlton entered the Third Division of the Lewisham League, which they won as undefeated champions, going top

after beating League title rivals Millwall Rangers 7-1. Moving to Woolwich Common the next season, Charlton Athletic were promoted once more, and the club began a rapid rise up through the district leagues. Local businessman Arthur Bryan, who owned a fish shop in East Street close to where the club had been founded, was elected club vice president, and it was through this fish connection that the club earned the nickname 'Addicks', a local pronunciation for 'haddock'. The story goes that not only did the players buy their fish from Arthur Bryan's shop, but the entrepreneurial fishmonger promoted his business by nailing a haddock to a post and parading it around the pitch while the match was played!

Although this young team from Charlton had rightly been making a deserved name for themselves as they progressed up through the local leagues, there was already a much more famous football club located just a few miles east of Charlton, Woolwich Arsenal, who were playing First Division football at their ground in Plumstead. Woolwich Arsenal had evolved from a works team, Dial Square, formed by Royal Arsenal munitions workers. When Woolwich Arsenal decided to uproot and move to North London, this left the way open for Charlton Athletic to establish themselves as the top club in south-east London.

At a board meeting held in a Charlton Village public house, the Bugle Horn, before the beginning of the 1913/14 season, a significant decision was made to change the status of the club from a junior side to senior amateur, and enter the London League, the London Senior Cup and the Kent Senior Cup. The committee also made the decision to relocate from the club's ground at Pound Park, off Charlton Lane, to the enclosed Angerstein Ground in Horn Lane, which allowed for the club to charge an entry fee at the gates. After another successful season, where the club finished as runners up in the London League, Charlton then entered the FA Cup for the very first time. When war broke out in 1914, match attendances began to fall away, and the board decided to close temporarily in March 1915.

Since the formation of the club ten years earlier, Charlton Athletic had finished champions of local district leagues on twelve occasions, winning more than twenty trophies in the process. Towards the end of the war, and after hostilities ceased, Charlton played in a series of friendly matches to raise funds for various war charities. In May 1919, the club was then invited to join the Kent League and move to a purpose-built ground off Woolwich Road, on a large area of land occupied by derelict sand and chalk pits.

By August 1919, gangs of labourers and volunteers had transformed the site into a sizeable football ground, which later became known as The Valley. The roped-off pitch was surrounded by huge mounds of sand and chalk, dug out from the excavations, for the supporters to stand upon.

Continued success on the pitch brought professionalism to the club at the end of the 1919/20 season, and when Charlton were then elected to the Southern League they began attracting crowds of up to 4,000 during the 1920/21 season. When the Football League made changes to the League structure the season after, Charlton were elected to join the new Third Division (South), playing their first League fixture at The Valley on 27 August 1921 against Exeter City.

Over the following six seasons, managed first by Walter Rayner, then Alex Macfarlane, followed by player-manager Albert Linden, and then (after a short period managing

Dundee FC) Alex Macfarlane again, Charlton finished in a respectable mid-table position for all but one season. After finishing second from bottom they were required to apply for re-election. Valley attendances were reaching in excess of 10,000, yet the club's financial situation became a serious cause for concern. Although a great FA Cup run during the 1922/23 season brought in some much-needed revenue, attendances began to fall away once the cup run was over. The board then made an extraordinary decision to move the club to Catford Mount, home ground to Catford Southend, believing this would lead to an increase in attendances, and a rise in gate receipts.

At the end of that season, after attendances had dropped to 1,000, the board, realising the error of their ways, took the club back home to The Valley. This would not be the last time that a Charlton Athletic board of directors had the misguided notion that moving the club from The Valley was a good idea.

Although attendances improved after the club returned, the move to Catford had left Charlton in a financial mess. On the field, however, the team were pushing for promotion. In the final match of the 1927/28 season, Charlton beat Walsall 2-0 away, knocking Third Division (South) leaders Crystal Palace off the top of the table on goal average. Charlton won promotion to the Second Division, and Palace were left in Division Three. Charlton finished in thirteenth place at the end of their first season in the Second Division, and the team continued to do well until relegation threatened during the 1932/33 season. The board sacked Alex Macfarlane in December 1932 after five straight losses, replacing him with former 'keeper Albert Lindon. Unable to put a halt to the poor run of form, Charlton were relegated at the season's end.

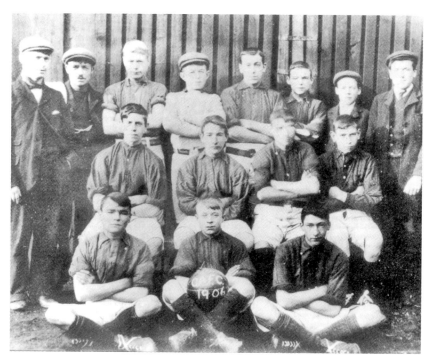

The boys from Lower Charlton, who formed the first team to wear the red-and-white kit of Charlton Athletic FC, 1905/06.

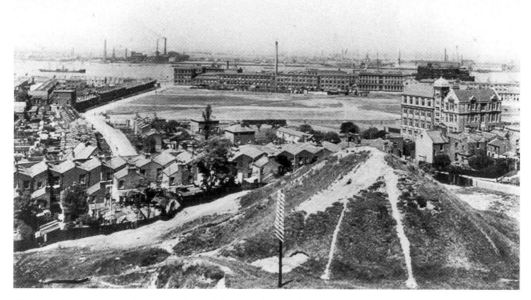

Siemens Meadow, the first Charlton Athletic playing field, situated between Siemens Telegraph Works, adjacent to the Thames, and Charlton Vale in the foreground, viewed from Cox's Mount, Maryon Park, 1900.

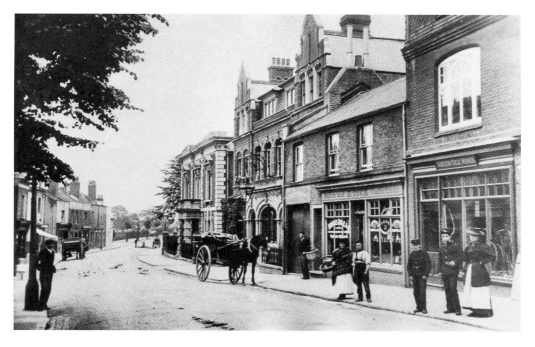

Charlton Village, late 1800s. Once a parish of Kent, Charlton became part of metropolitan London in 1855, and is now incorporated within the Royal Borough of Greenwich. As the village expanded, an area that stretched out and down towards to the river, became known as Lower Charlton.

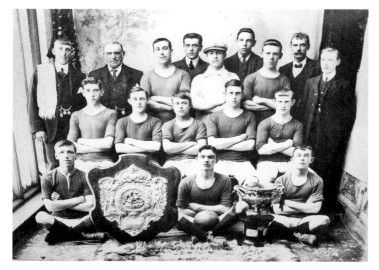

Lewisham and Woolwich League winners, 1908. Charlton Athletic were now playing at Woolwich Common, after the owners of Siemens Meadow continually dumped rubbish on the pitch, making it unplayable.

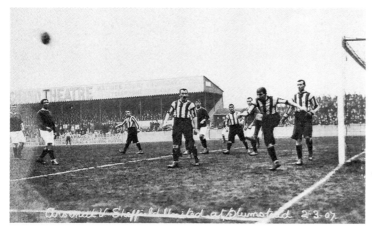

Charlton Athletic rivals Woolwich Arsenal, 1907. While the youthful Charlton Athletic team continued to progress up through the local leagues, the Royal Arsenal team was already well established, playing their third season in the First Division and attracting crowds of over 20,000.

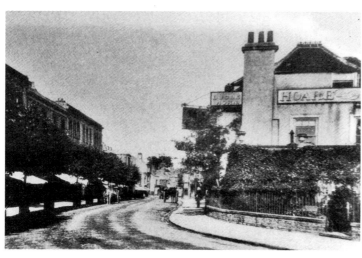

The Bugle Horn, Charlton Village, early 1900s. The board members of Charlton Athletic often held club meetings in welcoming local hostelries. At the club's annual general meeting, held at the Bugle Horn in May 1913, the decision was made for the club to adopt senior amateur status – the first steps towards professionalism.

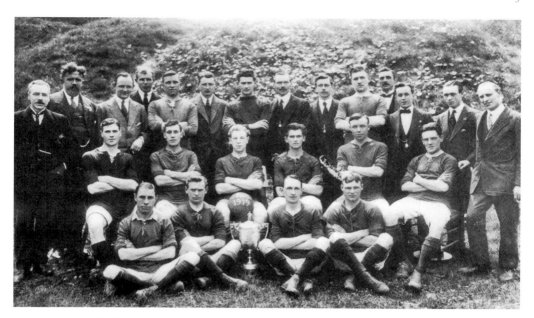

Team line-up with the Woolwich Cup on display, 1918/19 season. At the end of the First World War, Charlton lost the use of the Angerstein Ground, playing friendly matches for charity at Blackheath Rectory Fields and Charlton Park.

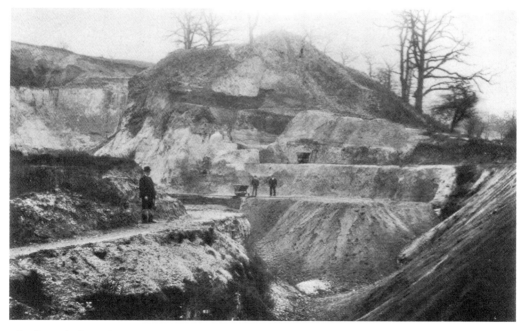

Charlton chalk and sand pits, off Woolwich Lower Road, late 1800s. Once an ancient settlement, the pits were worked out for industrial use until 1889. When the derelict area was then given over by the owners for communal use, Charlton Athletic acquired a large area to the west of the site to develop a purpose-built ground for the club.

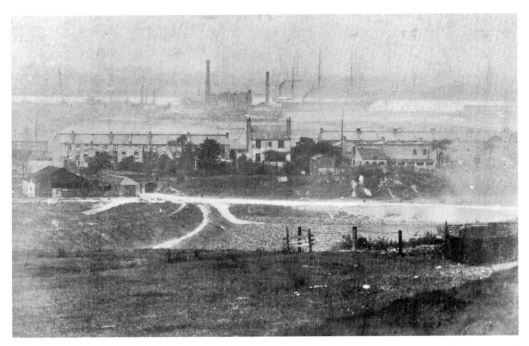

The site of The Valley viewed from Charlton Heights, late 1800s. Siemens Meadow is located far-off towards the right, close to the shore of the Thames, with the old *Warspite*, a Royal Naval frigate, moored up alongside. In the foreground to the left are the railway arches, which lead out onto what would eventually become Floyd Road.

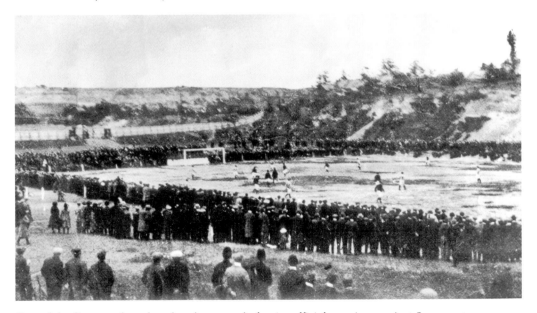

One of the first matches played at the ground after its official opening, against Summerstown on 13 September 1919, with Charlton winning 2-0. At the end of that season, Charlton Athletic became a professional football club.

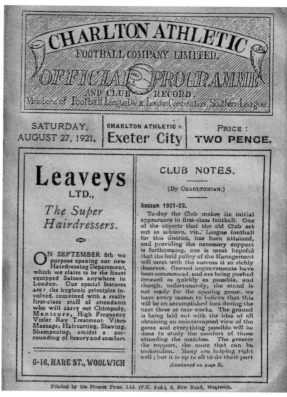

Right and below: A programme from Charlton's first match as a Football League club, against Exeter City, who were also playing their first game as a Football League club. The match was played at The Valley on 27 August 1921. Charlton won 1-0, with Tommy Dowling scoring Charlton's first League goal in front of 13,000 fans. Dowling also scored both goals in a 2-1 Southern League win over over Brighton & Hove Albion at The Valley on 4 September 1920, Charlton's first match as a professional football club.

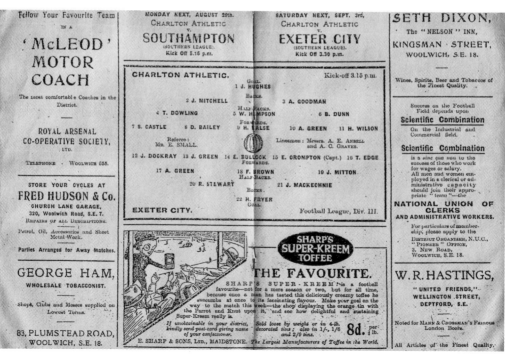

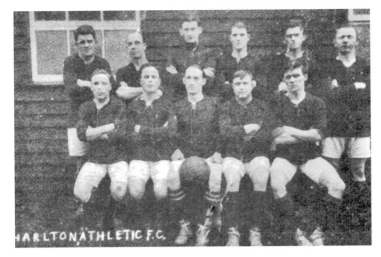

Team line-up, including Albert 'Mosky' Mills, seated front row second from right, who played his first Football League match for Charlton away against Northampton Town on 19 January 1922, making club history by becoming the only player to have represented Charlton in the club's first-ever match, and in the League.

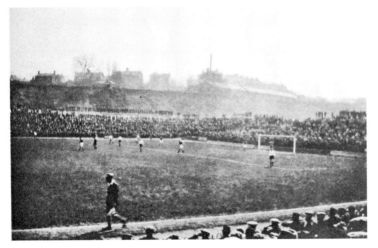

Supporters fill The Valley for a match during the early 1920s. Attendances over the first two seasons in the Third Division (South) averaged 6,000, and when Charlton went on a fantastic FA Cup run during the 1922/23 season, there were over 40,000 attending the fourth round at The Valley on 10 March 1923, when Charlton were finally knocked out, beaten 1-0 by eventual cup winners Bolton Wanderers.

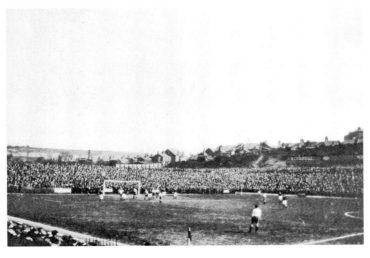

With only four losses at The Valley during the 1922/23 season, the team played some entertaining football, which brought Seth Plumb and Harold Miller their international call-ups; they were the first Charlton players to win full England caps – a marvellous achievement for a club playing Third Division (South) football. Along with the club's newfound notoriety came expectations of an increase in match-day attendances.

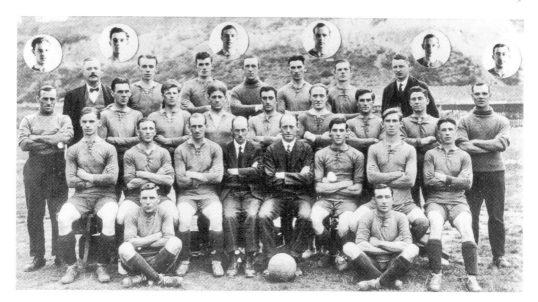

The first Charlton Athletic team to play in the Football League, 1921/22. Charlton manager Walter Rayner, seated in the front row with the ball, had been appointed as the club's first professional manager in 1920. In charge of the team for the first four seasons in the Third Division (South), he was sacked in May 1925. After an FA inquiry into the affairs of the club while under his management he was later suspended from football altogether.

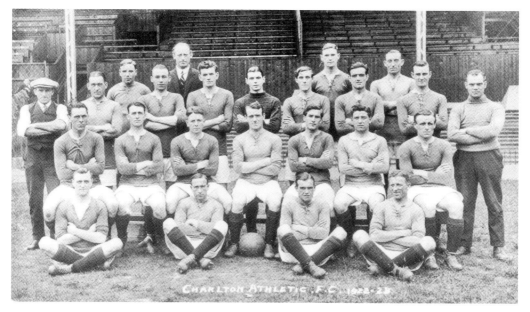

The Charlton team in front of the new Valley grandstand at the beginning of the 1922/23 season, when the Addicks went on their famous FA Cup run, knocking out Northampton Town and Darlington before meeting First Division Manchester City away and winning 2-1. Charlton then beat First Division Preston North End 2-0 at The Valley, with a gate of over 20,000, and West Bromwich Albion at home, winning 1-0 in front of over 30,000 fans.

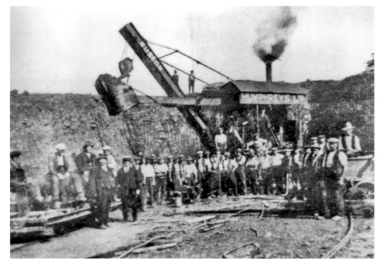

Charlton moved to Catford Mount, home of Catford Southend FC, for the 1923/24 season. Construction firm Humphreys began levelling out the site at The Mount in preparation for League football. However, Charlton did not play their first match in Catford until halfway through the season.

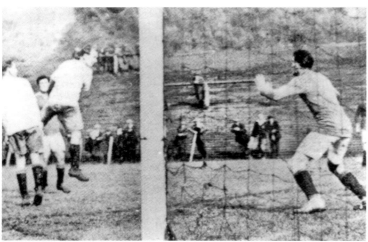

A trial match at The Valley shortly before the move to Catford in December 1923. Although League matches were to be played at The Mount, Charlton reserves continued to play theirs at The Valley, and at the end of the season, when the expected increase in attendances at The Mount failed to materialise, the board decided to move back home.

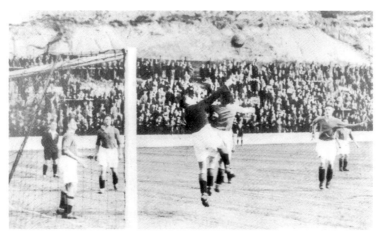

A match at The Valley after the club moved back for the 1924/25 season. The club's return was followed by increased attendances, where the highest home gate of the season, 35,000, came in a 2-0 loss against local rivals Millwall on 25 April 1924.

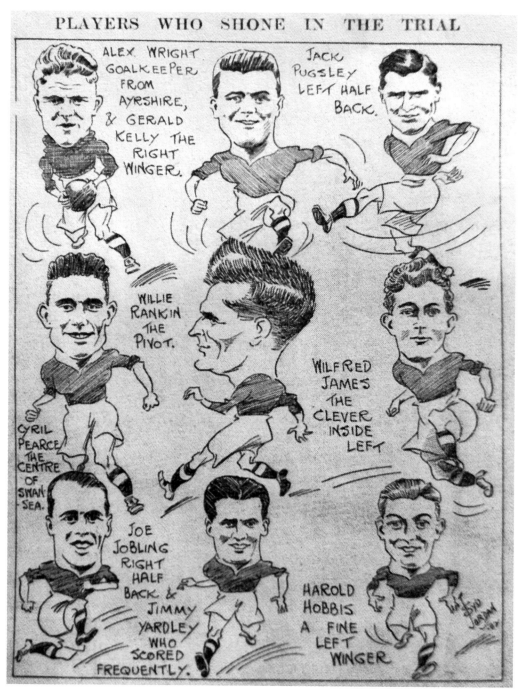

Syd Jordan's illustration of some of the Charlton players who took part in a pre-season trial match at The Valley in August 1932. This was the club's fourth season in the Second Division, after they were promoted as Third Division (South) champions in 1929. However, at the season's end Charlton finished bottom of the division and were relegated.

2

A MAN FOR ALL SEASONS

On Saturday afternoons during the early 1960s, before I made my first trip to The Valley, I would drop in at my gran's house, three doors down the road from where I lived, for afternoon tea and to watch the wrestling on ITV with my step-granddad. As soon as the last bout finished (usually featuring a contest between wrestling stars of the day, such as Mick 'not my ears' McManus, Jackie 'Mr TV' Pallo or Red Indian Billy Two Rivers) we would then change over to the BBC for Final Score on Grandstand, where the football results came through on a teleprinter, the very latest piece of information technology of its day.

Soon after all the results had come through, my great-uncle. Alf would usually appear after finishing his shift at the United Glass Bottle Works near Charlton, with a late copy of the evening paper tucked up under his arm. The results of any matches that did not finish before the paper went to press were left blank, and while he sat with us at the table drinking a large mug of tea, we would go through the results in the paper together, filling in any missing scores with those which had come through on the teleprinter, checking them off against his football pools coupon. Although my great-uncle Alf was born and raised in Greenwich, he had always been a Millwall fan and had persuaded my dad's older brother, Charlie, to follow them too. However, my dad chose Charlton Athletic, and when they were all together their conversation would inevitably turn to the fortunes of both south-east London clubs.

Charlton Athletic were then playing in the old Second Division, after they had been relegated from Division One in 1956, while Millwall, a club that had originated north of the Thames on the Isle of Dogs, were languishing down in the Fourth Division. One thing the clubs did have in common was that both had once been managed by the legendary Jimmy Seed; however, his time with Millwall came at the end of his illustrious career with Charlton, which had brought the club unparalleled success and fame. After his departure there were many Charlton followers who believed the achievements he brought to the club would never be equalled again. Most of my relations followed either Charlton Athletic or Millwall, dependent on which part of south-east London they had been born and raised in, with a majority of those brought up in Greenwich supporting the Addicks under the managerial care of the great Jimmy Seed.

Jimmy Seed came into management after a successful career as a player. Like many young boys brought up in the North East during the early 1900s, the only occupation on leaving

school came through working down in the pits. Due to his exceptional footballing skills, which had been recognised while still at school, he was soon signed on by Sunderland FC, where playing professional seemed a more likely career than mining for coal. Playing in the Sunderland reserves, a call up into the first team was not too far away. But no sooner had his football career begun than it was cut short by the outbreak of the First World War. Jimmy Seed signed up to join the Army and his West Yorkshire Regiment was then sent out to France. After three years at the front, he was invalided home after suffering severe gassing a month before the war ended. Following his recuperation, Jimmy Seed intended to resume his career playing football, but many clubs, including Sunderland, thought his playing days were over, as he was still suffering from the after-effects of the gassing. Proving them all wrong, he was signed up by Welsh club Mid Rhondda, and seven months later he joined Tottenham Hotspur, where he went on to captain the club to their 1921 FA Cup final victory, winning five England caps during his time with Spurs. Jimmy Seed then signed for Sheffield Wednesday, where he captained the Yorkshire club to two League titles before turning his hand to management with Clapton Orient, a small club situated just across the river from Charlton. Jimmy Seed had once played at The Valley while in the Spurs reserve team, and in his autobiography he recalls how dreary The Valley was, and how, when the match was over, the Spurs team had to change straight back into their dry clothes in a nearby hut as there was nowhere for them to take a bath or shower.

Wealthy timber merchants Albert and Stanley Gliksten had taken control of Charlton Athletic in 1931, prior to the club's relegation, and were now in need of a new manager after the club had dropped back down into the Third Division (South). Through the Gliksten's previous football connections with Clapton Orient and association with Arsenal manager Herbert Chapman, who knew Jimmy Seed well, they made the decision to offer him the position of Charlton manager, which he readily accepted. In his first year in charge Charlton finished in fifth place at the end of the 1933/34 season, just ten points off the top spot. During the early stages of the following season, young goalkeeper Sam Bartram arrived from the North East, recommended to Charlton by Jimmy Seed's brother, Anthony. In December 1934, Sam Bartram made his debut in goal, and then went on to play in a majority of the remaining matches of the season, where Charlton won promotion to the Second Division, eight points ahead of Reading. Charlton then won promotion for a successive season under the management of Jimmy Seed, on this occasion finishing in second place, one point behind Second Division champions Manchester United. For the very first time in the club's history, Charlton Athletic were now playing in the top division of the English Football League.

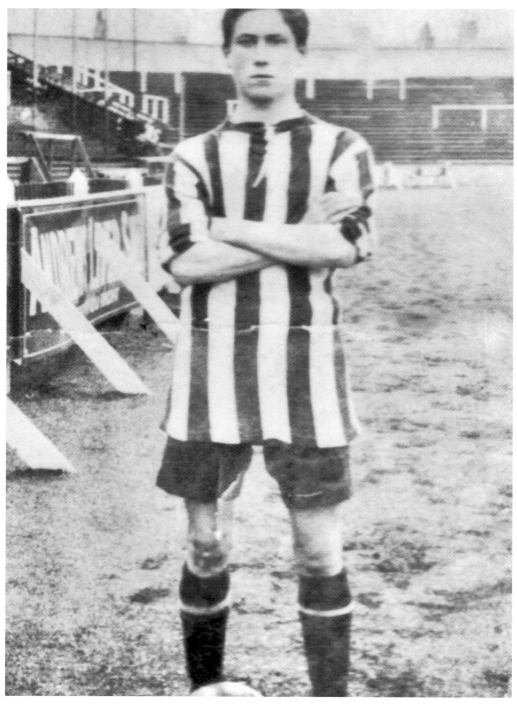

Jimmy Seed in Sunderland colours, 1914. While working down the pits, the future Charlton Athletic manager had been playing football for his local village team, Whitburn, South Tyneside, before he was signed on by the Rokerites.

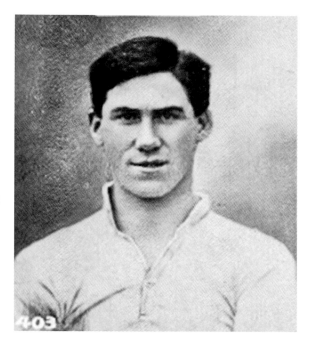

Free-scoring inside-forward Jimmy Seed joined Tottenham Hotspur from Mid Rhondda in 1920. After playing five reserve games, he was selected to play in the first team towards the end of the season, scoring two goals in five matches. Tottenham were promoted as Second Division champions and the following season Jimmy Seed played in all of Spurs' cup ties on the way to lifting the trophy, beating Wolverhampton Wanderers 1-0 in the final at Stamford Bridge. During seven seasons with Spurs, Jimmy Seed made 254 League and cup appearances for the club, scoring seventy-seven goals, before transferring to Sheffield Wednesday in August 1927.

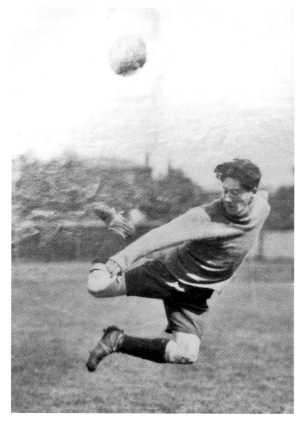

Club captain Jimmy Seed won two First Division titles with Sheffield Wednesday in 1928 and 1929, making 146 League and cup appearances for the club, and scoring thirty-seven goals. In 1931, he retired from playing to take up the managerial position at Clapton Orient.

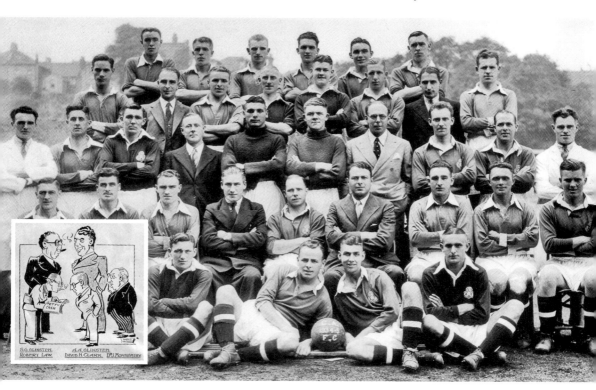

Above: Charlton Athletic, 1934/35, promoted as Third Division (South) champions under Jimmy Seed's management. From left to right, back row: Green, Logan, Raikes, Gee, Thomas, Robinson. Fourth row: Tann, Arnott (director), T. Smith, Butt, Boulter, Wilkinson, Phillips (assistant secretary), Doherty. Third row: Hird (assistant trainer), Johnson, Turner, Clark (director), H. Wright, A. Wright, S. Gliksten (director), Harris, Jobling, Trotter (trainer). Second row: Stephenson, N. Smith, Pulling, Seed (secretary-manager), Oakes, A. Gliksten (chairman), Ivill, Forster, Rist. Front row: Brown, Dodgin, Hobbis, Prior.

Inset: The men behind the team. In 1931, the Gliksten brothers, owners of one of the world's largest timber merchants, were persuaded to buy into the club by director David Clark. Clark, an employee of Humphreys Limited, had been placed on the board after the club failed to pay the contractors all that was owed for work carried out at the ground, which included the building of the main grandstand. After taking on the club's liabilities, paying off debentures and securing club losses, Albert Gliksten was appointed club chairman, with brother Stanley taking up the position of deputy chairman. David Clark remained on the board as a director. Stanley Gliksten once said, 'to take over a football club you had to be a multimillionaire, a football lover and a bloody fool' – wise words indeed. Later, as Charlton progressed up through the divisions, the Gliksten brothers were joined on the board by Robert Law, and Dr John Montgomery, the club's medical officer, a charming man with a great personality who was often invited to attend functions as an after-dinner speaker.

Right: Jimmy Seed with young 'keeper Sam Bartram standing behind him. Bartram was brought in from a North East mining town club, Boldon Villa, in 1934. Bartram would go on to make a record 623 League and cup appearances during his sixteen seasons playing in goal for Charlton. Starting out playing in the left-half position, Bartram took to goalkeeping when the Boldon Villa 'keeper was injured, and he volunteered to go in goal for a match; a position which eventually set him off on his professional career in football.

Below: First Division Charlton Athletic, 1936/37. A second successive promotion took the Addicks up into the top division of the English Football League for the first time in the club's history. From left to right, back row: Calland, Lancelotte, Mordey, Hobbins, Ford, Shreeve. Fourth row: Cann, G. Green, Butt, Williams, Hiffle, Brown, Thomas, R. Green, Mallett, Tann. Third row: Hird (assistant trainer), Chase (groundsman), Jobling, Smith, Tadman, Turner, Bartram, Welsh, Pearce, Rist, Boulter, Trotter (trainer). Second row: Clark (director), S. Gliksten (director), Prior, Seed (secretary-manager), A. Gliksten (chairman), Jimmy Oakes, Arnott (director), Phillips (assistant secretary). Front row: Wilkinson, Robinson, Hobbis, John Oakes, Stephenson.

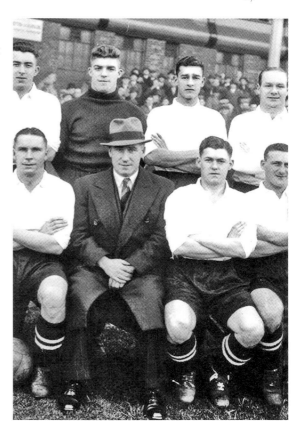

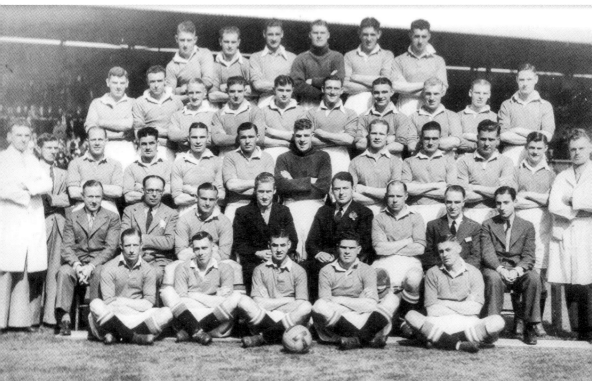

YEARS OF TRIUMPH AND GLORY

When I first became interested in football during the early 1960s, the top clubs of the day were Sheffield Wednesday, Everton, Manchester City and Arsenal, who were all playing in the old First Division, whereas my local club, Charlton Athletic, were jogging along in the division below. Any chance Charlton had of meeting a club from the top division only came if they were drawn out to play each other in a cup tie.

When those same clubs had been winning First Division titles back in the 1930s, the opportunity for Charlton to play them each week came after they made football history by becoming the first club to be promoted in two consecutive seasons from Third Division to First Division. After promotion into the top division in 1936, to everyone's complete surprise, Charlton finished the season as runners-up, three points behind champions Manchester City. Valley attendances during Charlton's first season in the First Division averaged 31,086, with the largest gate of 68,160 coming against Arsenal, and although Charlton lost the match 2-0 – the only defeat at home that season – Arsenal's goals were scored when Charlton had a defender off the pitch receiving treatment.

For the first time in the club's history a healthy profit was made, and after the interest created by Charlton's remarkable first year in the First Division, club chairman Albert Gliksten secured a lucrative invitation to tour North America during the close season.

In the following season, Charlton finished in fourth place, and then third the season after. Just when expectations were at an all-time high, with the supporters believing the First Division title might soon be heading towards south-east London, war broke out, and the 1939/40 season finished almost before it began. With only three matches played, the Football Association cancelled all football contracts and League football ceased for the duration of the war.

In an attempt to keep the footballing population happy, clubs were later given permission to play in a series of friendlies and regional matches, which at first did not capture the imagination of the supporters and matches were poorly attended. Later, as people adjusted to the uncertainties of war, and after a great deal of negotiation between the clubs and the Football League, regional leagues were formed. Charlton Athletic competed in the London League during the 1941/42 season, and in the Football League (South) from then on up until hostilities ceased.

Charlton also took part in a War Cup competition, reaching the Football League (South) final at Wembley twice, losing to Arsenal in 1943, and then beating Chelsea in

1944. Charlton then faced Northern Cup winners Aston Villa in the Alexander Cup at Stamford Bridge on 20 May 1944. With the score 1-1 at full-time, and with no prospects of deciding a winner in extra time or in a replay, due to the threat of air raids and transport restrictions, both clubs were presented with a trophy.

At the end of hostilities in 1945, football continued in the regionalised format up until the end of the 1945/46 season. The FA Cup competition resumed, replacing the War Cup, and in the first final after the war, Charlton were back at Wembley for their third cup-final appearance in four years. Charlton made history on the way to Wembley, becoming the first club to lose a cup tie and still make it through to an FA Cup final. The loss came at Fulham, when FA Cup ties were then played over two legs – home and away – Charlton going through on goal average. Beaten in the final 4-1 by Derby County, Jimmy Seed told his players that Charlton would go one better next year and win the cup.

League football resumed in the 1946/47 season, and Charlton, back in the First Division, went on another fantastic FA Cup run, winning a place in the final against promotion-chasing Second Division Burnley. The 1947 FA Cup final was played in March, before the season's end, when Charlton were in a poor run of form and down towards the bottom half of the table. Due to both clubs' respective positions in their divisions, Charlton were considered the underdogs on the day.

In what was a very unremarkable FA Cup final, the match went into extra time with the score 0-0 after ninety minutes. Then, with just over six minutes of extra time remaining, the ball landed at the feet of winger Chris Duffy, through a glancing header from Charlton Athletic captain Don Welsh. Duffy hit the ball on the half-volley, straight past the Burnley 'keeper and into the back of the net. Charlton Athletic had won the FA Cup, becoming only the third London club to that day to have lifted the world's most prestigious domestic football trophy. Although finishing the season in nineteenth place, Charlton Athletic consolidated their position in the First Division during the following nine seasons, becoming one of the best-supported clubs in England.

Throughout those nine seasons, when Jimmy Seed had brought football success to south-east London, the Charlton Athletic board of directors had been reluctant to substantially invest in the playing staff or in the development of The Valley, which at one time had been considered as a possible venue for staging international matches. Jimmy Seed was required to run the club on the proverbial shoestring budget, using his football scouts to bring in foreign signings and players on short-term deals. At the beginning of the 1956/57 season, Jimmy Seed had been managing Charlton Athletic for twenty-three years, and at the age of sixty-one was making plans for his retirement. With the Charlton playing staff virtually unchanged from the previous season, apart from the great Sam Bartram retiring to take up the managerial role at York City, no one at the club had any concerns about how the team would perform during the forthcoming season.

When Charlton made a very poor start, losing their first five matches, the directors, fearful of the club losing its First Division status, decided to sack Jimmy Seed after an 8-1 defeat by Sunderland at Roker Park, the club where he began his long, successful career in football. The directors made an announcement that Jimmy Seed had resigned due to ill-health, and the sacking of the man who had taken Charlton Athletic from the Third Division (South) up to playing at the highest level of domestic football, securing cup glory along the way, was hushed up.

The directors appointed club trainer Jimmy Trotter, Jimmy Seed's right-hand man, as the new Charlton Athletic manager nine days later, and although the series of losses were halted, overall results remained poor. With just nine wins and four draws coming throughout the remainder of the season, Charlton Athletic were relegated to the Second Division in April 1957.

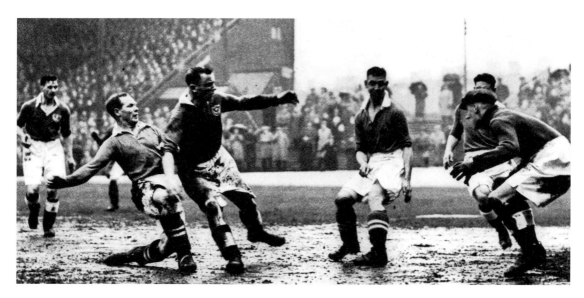

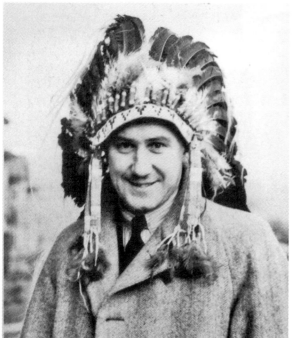

Above: Charlton Athletic *v.* Portsmouth on a wet afternoon at The Valley, in a First Division match prior to the outbreak of the Second World War. Harold Hobbis looks on as Don Welsh scores past the Pompey 'keeper.

Left: When Charlton toured North America in 1937, Jimmy Seed was made an honorary Indian chief when the Addicks played Saskatchewan All-Stars in Saskatoon, Canada, winning 12-2. After the game, the Native Canadian Indian tribe were presented with the match ball. During the tour Charlton played thirteen matches in just over a month, winning twelve and drawing one.

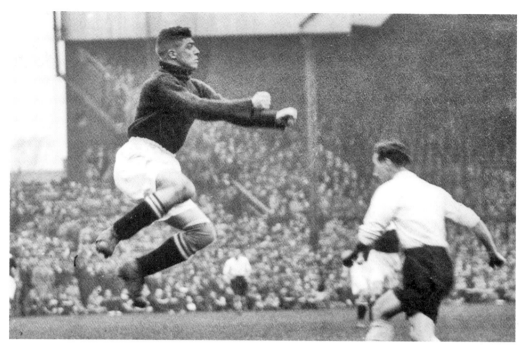

A young Sam Bartram in athletic flight at The Valley in a match against Arsenal on 17 October 1936. Although losing 2-0, the Addicks' first home defeat in eighteen months, Bartram was now well-established as Charlton's first-choice goalkeeper.

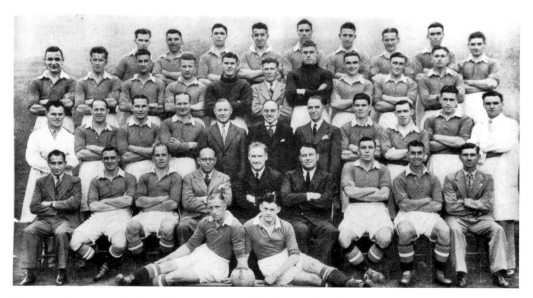

The second season in the First Division, 1937/38. Finishing in fourth place, with home crowds averaging 28,336, Addicks supporters would be justified in expecting that Charlton Athletic would now become a major force in football. However, the Gliksten brothers, astute businessmen as they were, were forever reluctant to spend too much of their hard-earned money on player and ground investment.

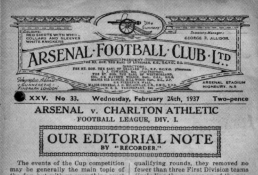

ARSENAL·FOOTBALL·CLUB·LTD

XXV. No 33. Wednesday, February 24th, 1937 Two-pence

ARSENAL v. CHARLTON ATHLETIC
FOOTBALL LEAGUE, DIV. I.

OUR EDITORIAL NOTE
BY "RECORDER."

The events of the Cup competition may be generally the main topic of the day, but with us everything must give place this afternoon to the visit of Charlton Athletic. A call from a fellow-London club is always an event; when it is paid by a guest who has not come to us before that event is of particular note; but in Charlton's case the occasion is of the highest possible importance. It is not only that Charlton and ourselves are at the moment the protagonists in the battle for the Championship, Charlton's own astonishing record since 1934 focuses all attention upon them. Top of the Third Division in 1934-35; second in, and promoted from, the Second Division in 1935-36; and now top of the First Division with two-thirds of 1936-37 zone. In that period they have scored 154 points out of a possible 226, winning 63 matches, losing 22, and drawing 28, scoring in the process 227 goals against their opponents' 142.

Surprising.

Charlton have had a knack of springing surprises since they joined the League as recently as 1921. Few will forget the sensation they created in their Cup run of 1923 when, after knocking out Northamp-

qualifying rounds, they removed no fewer than three First Division teams (including the runners-up of the preceding year) in Manchester City, Preston North End, and West Bromwich Albion. And then, in the Fourth Round, Bolton Wanderers, who ultimately won the Cup, only beat them by a goal to none. In 1929 they won promotion, another sensation for they only just headed Crystal Palace on goal average. After four years in the Second Division they fell with Chesterfield in 1933, at which point Mr. James Seed took over the managership. A quiet building year took place in 1933-34, and then came the flood! How they have fared since August, 1934, we all know. On October 17th last we beat them by 2—0 at the Valley and we hope to do so again to-day. Such a victory would leave us level on points with each other for first place, with Portsmouth, Brentford and others not yet out of consideration by any manner of means. It should be the best race for the Championship since Huddersfield Town and Cardiff City ran neck and neck in 1923-24.

* * *

BURNLEY OVERWHELMED.

It is often glibly said that the winners of the Cup go out in their

Left: The first competitive match against old neighbours Arsenal at Highbury, 24 February 1937, after Charlton's promotion to the top division. At the time of their meeting, both clubs were battling for the First Division title. The Addicks drew the match 1-1 in front of 60,568 fans, a lock-out on the day. At the season's end Charlton finished second in the division, with Arsenal taking third place.

Below: Charlton take on Blackpool at The Valley, 11 March 1939. Bert Turner is seen left, and John Oaks defends their goal in the Addicks' 3-1 win over the Seasiders. With just three matches played at the beginning of the following season, war broke out, and League football came to an end.

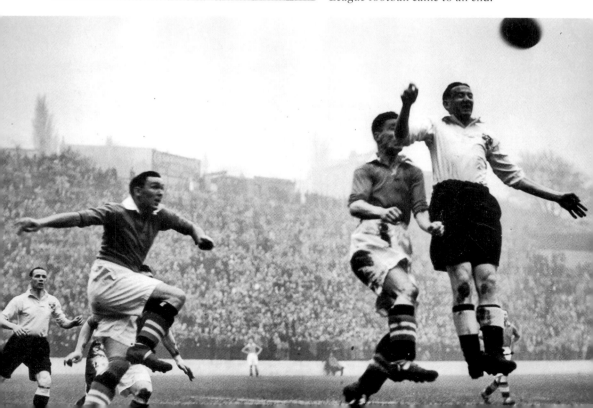

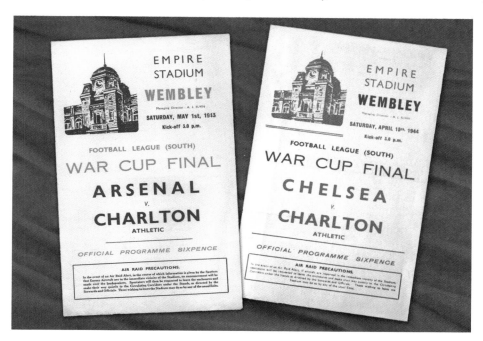

Football League (South) Cup final programmes, 1 May 1943 and 15 April 1944.

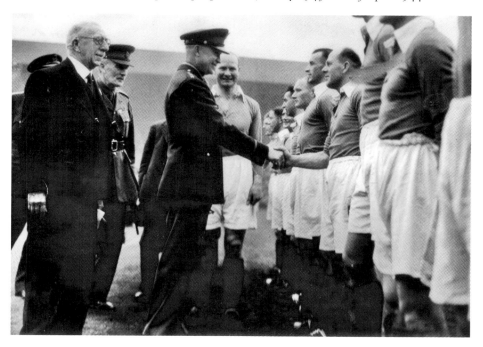

Five-star General Dwight D. Eisenhower being introduced to the Charlton players by Captain Don Welsh at Wembley for the War Cup final against Chelsea on 15 April 1944. After losing out to Arsenal the year before, the Addicks were determined to bring home their first domestic cup since joining the Football League.

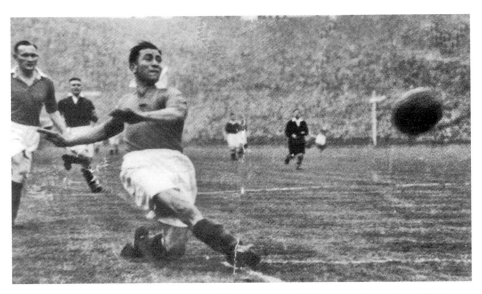

Charlton Athletic forward Charlie Revell scores one of his two goals against Chelsea at Wembley in front of 85,000 fans. Going down to a penalty after twelve minutes, Revell scored the equaliser four minutes later and then, following a goal from Don Welsh, he also scored Charlton's third.

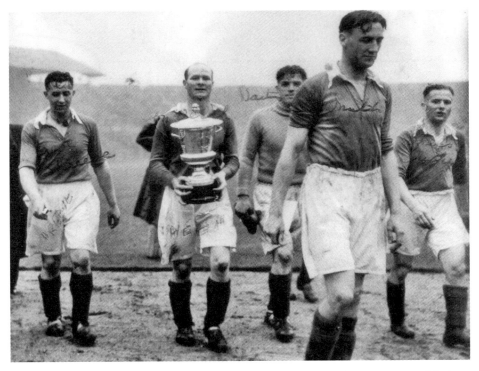

Charlton win the cup, beating Chelsea 3-1. Left to right: Jack Shreeve, Don Welsh, Sam Bartram, George Smith, and guest player Chris Duffy, who Jimmy Seed would later sign.

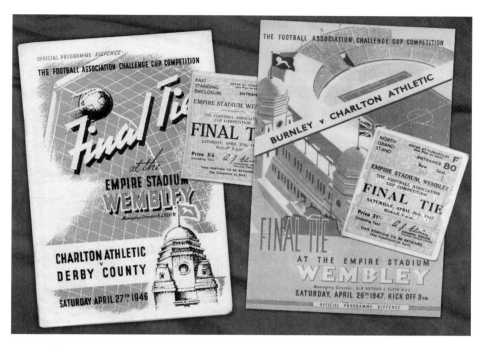

FA Cup final programmes, 27 April 1946 and 26 April 1947. At the end of hostilities, football returned to normality and clubs reverted to playing League football and competing for the FA Cup. Charlton returned to Wembley for their first FA Cup final appearance in 1946 against Derby County, and a year later they were back again, this time up against Burnley.

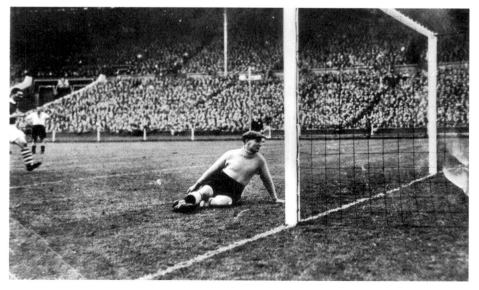

The 1946 FA Cup final played against Derby County. Burt Turner, left, who had scored an own goal a minute earlier, hits a free-kick past 'keeper Woodley to equalise for Charlton on eighty-one minutes, taking the final into extra time. Derby, who had been the better side, scored three more goals to win the final 4-1.

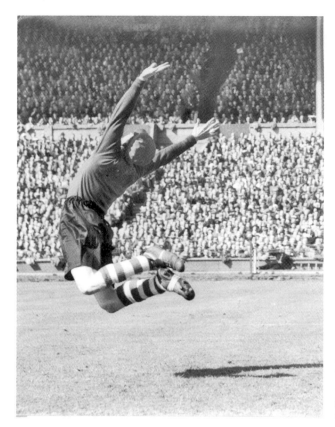

Left: Back at Wembley for the 1947 FA Cup final, the great Sam Bartram makes a flying save to tip the ball over the bar.

Below: In a final dominated by both teams' defences, the 98,215 fans in attendance at Wembley watched the game conclude in a 0-0 draw, taking the final into extra time.

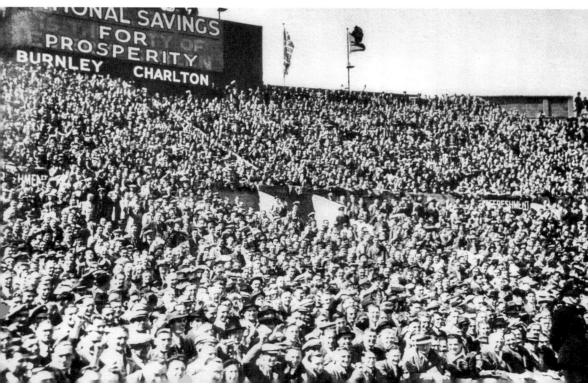

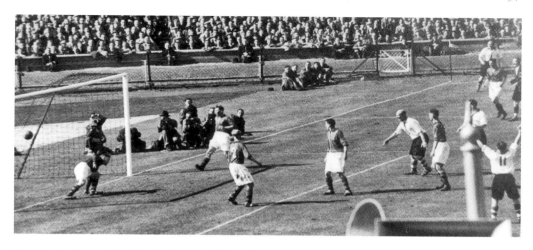

Charlton's forward, Chris Duffy, far right with arms raised, celebrates scoring the goal that won Charlton the FA Cup. Duffy's powerful shot from 14 yards flew past the motionless Burnley 'keeper, Jim Strong, and into the back of the net six minutes before the final whistle, Charlton winning the match 1-0.

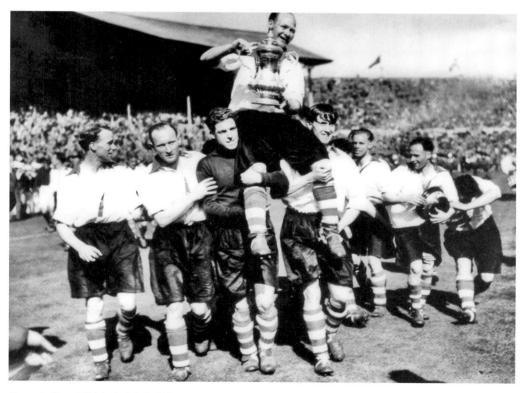

Captain Don Welsh, held aloft by teammates Sam Bartram and Peter Croker, proudly shows off the FA Challenge Cup, accompanied by, from left to right: Gordon Hurst, Bill Robinson, Bert Johnson, Chris Duffy, Jack Shreeve. The other team members not shown in the image were Tommy Dawson, Harold Phipps and Bill Whittaker.

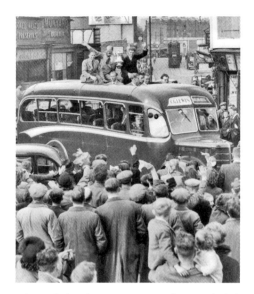 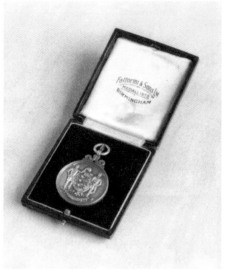

Above left: The FA Cup proudly paraded through the streets of the Borough of Greenwich, packed with Charlton supporters after the team's triumph at Wembley. Local coach operator C. G. Lewis had supplied Charlton's transport for the club and its supporters since the early 1900s, travelling to all parts of the country for away matches in both League and cup.

Above right: The FA Cup winner medal presented to Charlton defender Peter Croker, who had missed out on playing in the 1946 final after fracturing his leg ten days before against Tottenham Hotspur at The Valley. Croker, who had played in all the cup ties up to the 1946 final, had been tipped to win his first international cap, and lost out on the opportunity to play for England against France and Switzerland.

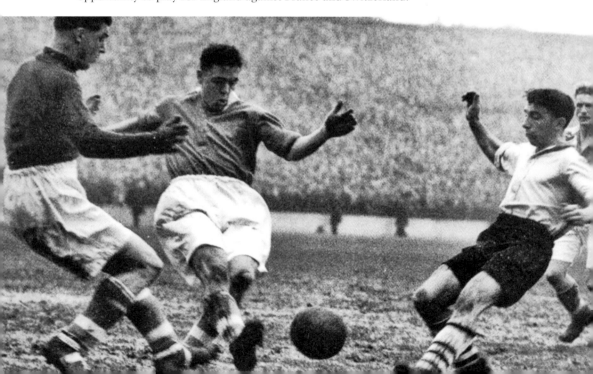

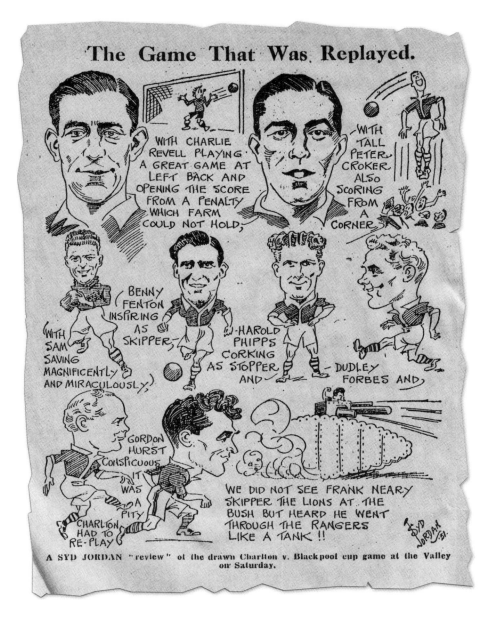

Above: Syd Jordan illustrates Charlton's draw in the third round of the FA Cup against Blackpool, with reference to local neighbours Millwall, 6 January 1951. With only three minutes of the match remaining and Charlton winning 2-1, Stan Mortenson scored the equaliser, taking the tie to a replay at Bloomfield Road.

Opposite below: Back on the FA Cup trail, Bartram and left-back Frank Lock defend an attack from Stockport County's forward at The Valley on 24 January 1948. The cup holders had knocked out Newcastle United in the previous round 2-1, then beat Second Division County 3-0 to set up a fifth-round tie against Manchester United.

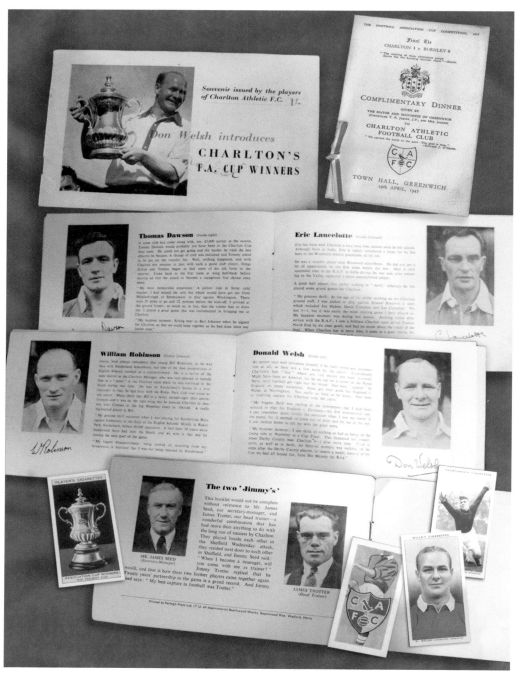

Charlton Athletic souvenirs: a signed pamphlet celebrating Charlton's 1947 FA Cup win, produced by the players and sold to raise funds after receiving meagre rewards financially, for winning the FA Cup; a menu from the complimentary dinner held by Greenwich Borough Council at the Town Hall, where the dishes served were named after the Charlton players; and a few of many football collector cards issued in packs of cigarettes, featuring famous clubs and players of the day.

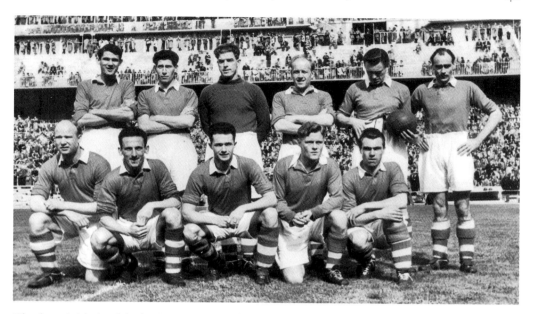

Charlton Athletic visit the Santiago Bernabéu Stadium to take on Spanish giants Real Madrid, 24 April 1955. The game took place on Sunday, the day after Charlton played away at Everton, the players flying to Spain after the match. Charlton, leading 2-1 by half-time, eventually lost the match 5-3. The team then flew back home to take on Manchester United at The Valley two days later.

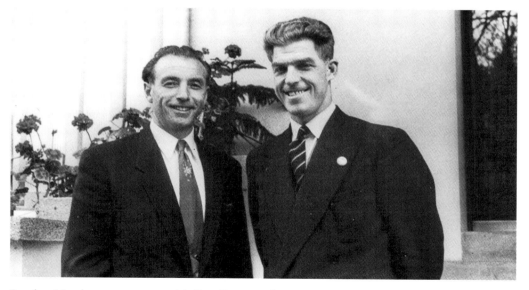

Stanley Matthews meets up with Sam Bartram for a representative match during the 1950s. Charlton's team would certainly have improved if they had signed this wizard on the wing, which Charlton once had the opportunity to do. After gaining promotion to the First Division, Jimmy Seed offered Stoke City £13,000 for Matthews, a huge transfer fee at the time, but the Potters turned him down, much to the relief of the Charlton board, who did not believe Matthews was worth the fee. Seed, however, believed the club should have bought him whatever the cost.

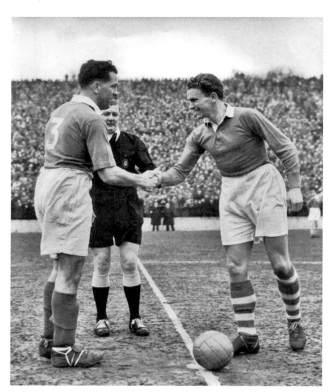

Left: Swedish international forward Hans Jeppson (right) attracted a crowd of over 34,000 to The Valley for his last match with Charlton against Portsmouth on 31 March 1951. Made captain on the day, he was presented with an inscribed cup from the supporters, before being whisked off on a river launch after the match, to catch a boat from Tilbury back to Sweden in time for his wedding day. With Charlton drifting down towards the bottom of the First Division, Jeppson had been drafted in by Jimmy Seed to score the goals to keep them safe, which he did, hitting nine in eleven matches, a hat-trick coming in a 5-2 win at Highbury, Arsenal's biggest home defeat for over twenty years.

Below: During an exceptional match played against Arsenal at Highbury on 11 December 1954, in front of almost 40,000 fans, Charlton had twenty-three shots during the game, but could only score from an own goal, while Arsenal had thirteen shots, scoring three.

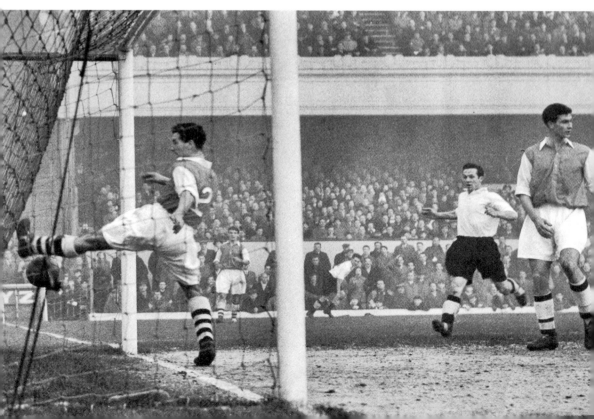

SAM'S DAY

Yes, it was quite a day when Sam Bartram, the great Charlton goalkeeper, celebrated his 500th appearance for the club.

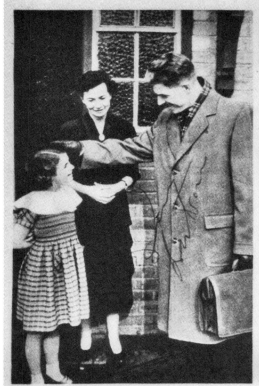

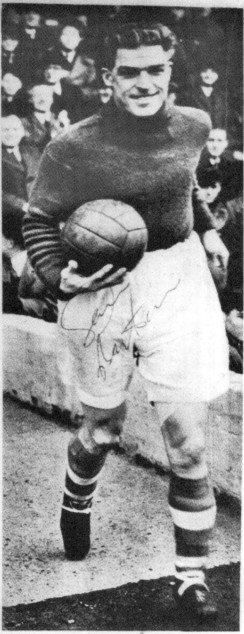

It began happily with a smile from his daughter Moira as he left home on his way to The Valley . . .

Then, captain for the occasion, Sam was first out of the dressing-room.

Sam Bartram's 500th game for Charlton Athletic, 6 March 1954. A magazine featuring a day in the life of Sam Bartram, leading up to this momentous occasion, where Charlton won the match 3-1 against Portsmouth. Before kick-off, Jimmy Dickinson, the Pompey captain, presented Sam Bartram with a special cake to commemorate the game.

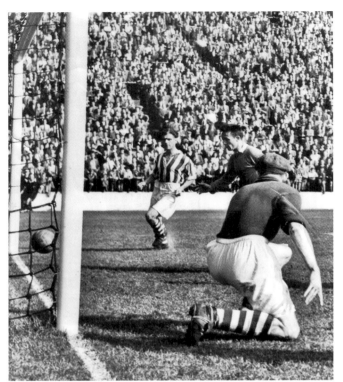

Left: Bobby Ayre scores Charlton's second goal in their 2-1 win over Huddersfield Town, 28 December 1954. Charlton's attendances by this time had dropped to around 25,000, not such a great surprise, as after the sale of players, which included Charlton's top goalscorer Eddie Firmani, the money the club made had not been reinvested in the team.

Below: The Charlton Athletic team, 1955/56. From left to right, back row: White, Hammond, Campbell, Hewie, Bartram, Chamberlain, Townsend, Ellis, Ayre. Front row: Hurst, Gould, Ufton, Leary, Ryan, Kiernan. Sam Bartram's final season with the Addicks came when the team were playing some excellent football, and although finishing in fourteenth place, there was no indication of the poor run of form to come.

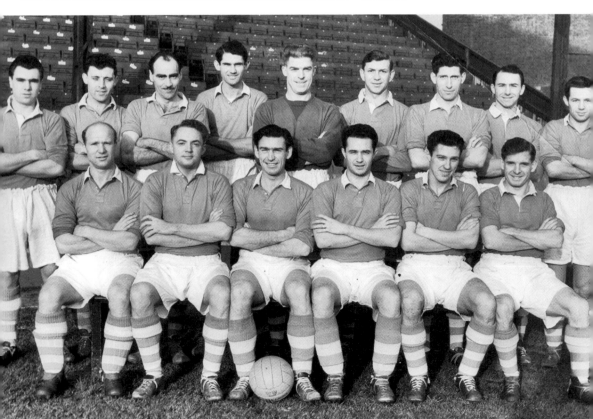

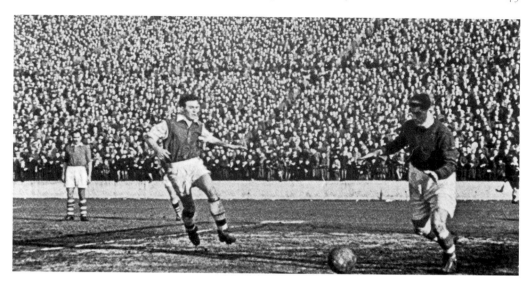

A visit from Arsenal to The Valley on 10 March 1956, Sam Bartram's last match for Charlton Athletic, after playing a record 623 League and cup matches for the club he joined as a raw young 'keeper in 1934. Bartram kept a clean sheet on the day, Charlton beating Arsenal 2-0, both goals scored by Jimmy Gauld. After retiring from playing, Sam Bartram went on to manage York City.

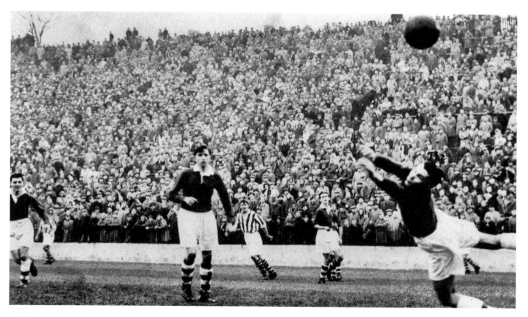

Eddie Marsh, Sam Bartram's long-serving stand-in, makes a flying save after taking over in goal for a majority of the 1956/57 season. Although Marsh had made a few League appearances for Charlton since first joining the club in 1945, his opportunities had been limited with such a great 'keeper as Bartram in goal. When he did get a run in the side, after Charlton's two other 'keepers, Frank Reed and Willie Duff, had taken a turn, the defence was in such a poor run of form that goals were conceded at an alarming rate, which Marsh could do nothing about.

4

FAMILY OF ADDICKS

In their first season back down in the Second Division, Charlton narrowly missed out on winning a promotion straight back into the top division after losing 4-3 to Blackburn Rovers at The Valley in the final match of the season, watched by over 56,000 fans. Blackburn went above Charlton to take second place by just one point. Attendances were up during the 1957/58 season, averaging 22,249; however, financially the club made a loss of over £8,000 – a huge amount at the time. The board, now joined by Stanley Gliksten's sons Michael and David, were reluctant to make any substantial investment to improve the team, possibly because Charlton were regularly finding the back of the net, scoring 107 goals during the 1957/58 season, ninety-two the next, ninety the season after, and a total of ninety-seven at the end 1960/61 season. However, Charlton were letting in almost as many as they scored. Although there were some memorable high-scoring matches at The Valley during those first few seasons down in the Second Division, attendances fell away, along with any expectations the supporters may have had that Charlton would regain their place in the First Division. In just three seasons Charlton's average home attendance had halved, and with the local population finding other sporting events to occupy them during their leisure time, including most of my Charlton-supporting family members and their friends, the huge crowds that had once filled The Valley were now long gone.

By this time, my dad and his brother had also left football behind and were now involved in a different type of sport: greyhound racing, where they owned dogs that competed at tracks in New Cross, Crayford and at Charlton. My dad would take me along to the track on Saturday evenings when their dogs were running, which was a great night out, and occasionally, if you were lucky, you might come across a few Charlton Athletic players having a night out at the Charlton Stadium after playing in a match that same Saturday afternoon.

In those days, many Charlton players and their families lived in the local area, where they socialised with supporters in the pubs and clubs of Charlton, Woolwich and Greenwich. A work colleague of my dad became good friends with goalkeeper Sam Bartram, a friendship which lasted long after Sam retired. Another of my dad's friends enjoyed many nights out at the Humber Club in Greenwich with Charlton forward Johnnie Summers, who scored five goals in Charlton's dramatic 7-6 win over Huddersfield Town at The Valley in 1957.

I only came to know of these famous Charlton footballers through the stories told to me by my family members and their friends. By the time I began attending matches at The Valley, Charlton Athletic were just another average, mid-table Second Division team, where any good players that came through the ranks or were brought into the club for nominal fees would soon be sold on for a profit to balance the books.

To this day I do not know why I took to a club that was in rapid decline. Perhaps it was the tribal instincts that are within us all, where loyalty to a club comes through long family allegiances. Once you have taken up with a club, especially one local to where you were born and raised, that club becomes part of your life, through the good times and the bad, and no matter what the future may hold those allegiances will never change.

The Charlton manager, on the day I first stood upon the terraces behind the south goal at The Valley, was Bob Stokoe, who was just over halfway through his first season in charge. At the end of the 1965/66 season, Charlton finished in sixteenth place with a lowly thirty-eight points. The following season Charlton avoided relegation by just six points, and then, when results did not improve at the start of the 1967/68 season, the directors decided a change in management was needed.

While out on my Sunday morning paper round, a school friend came speeding around the corner on his bike, Sunday paper in hand, shouting out that 'Stokoe's been sacked!' It was the first of many managerial sackings that have taken place during the time I have been supporting Charlton Athletic.

South African born Charlton forward Eddie Firmani was offered the managerial position, an appointment fully supported by the fans, confirmed by an increase in attendances at The Valley after he took on the job. Although my first match at The Valley had come two seasons before, it was during the years Eddie Firmani was in charge that I became a dedicated Charlton Athletic supporter.

The first season under Eddie Firmani was a time for consolidation, where Charlton finished in fifteenth place on thirty-seven points. The next season began with a 4-3 home loss to local rivals Millwall, but Charlton then went on a nine-match unbeaten run; by September 1968, they were top of the Second Division. Charlton supporters, myself included, began to believe that promotion was a real possibility. Although Charlton continued to play some good football throughout the remainder of the season, they could not sustain their challenge, eventually dropping off the top spot to finish the season in third place below Derby County and Crystal Palace; not good enough in those days to earn promotion, with only the top two clubs going up. Although it was disappointing to have lost out in the promotion race, it was not surprising that promotional expectations were high at the beginning of the 1968/69 season.

Dreaming of First Division football, I bought my first Charlton Athletic replica kit from Nickels Sport Shop on Trafalgar Road, which I proudly wore for school games lessons to show I was a true Charlton Athletic supporter.

Results during the season were not what we had expected, and after a poor run, with Charlton lingering far too close to the foot of the division, the directors made a change of management, sacking Eddie Firmani and replacing him with assistant manager Theo Foley. By the end of the season Charlton escaped relegation by four points. The team fared no better the following season, finishing third from bottom for the second season

in a row. By the end of the 1971/72 season, Charlton's luck had finally run out, and they were relegated on the last day of the season, beaten 5-0 at Blackpool.

Ever the loyal supporter, I carried on attending matches at The Valley, however there were many more Charlton supporters deciding enough was enough, and attendances dropped to an average gate of 5,658. Theo Foley brought in a player from Luton Town, Derek Hales, who would go on to become Charlton's record goalscorer. Matches were certainly entertaining during Charlton's time in the Third Division – while the forwards were knocking the ball into the opposition goal with regularity, the defence were letting just as many in! After another managerial change for the 1974/75 season, Charlton won promotion back into the Second Division under the guidance of Andy Nelson. Although attendances began to improve, along with the club's financial turnover, profits were relatively poor – a situation that carried through into the late 1970s. If it had not been for money made on the sale of the club's better players, Charlton's financial predicament would have been much worse.

Relegation came to the club again in the 1979/80 season. Charlton finished bottom of the Second Division, which did not help the club's precarious financial situation. After a season in the Third Division, Charlton won promotion under former player Mike Bailey, who had first taken on the role of chief coach when Nelson became the club's general manager. However, his success with the club was all to brief, and he resigned to take up the manager's position at Brighton & Hove Albion, with their manager Alan Mullery coming the opposite way. The Charlton supporters were now expecting a long period of stability after the former Fulham, Tottenham and England midfielder had been appointed manager.

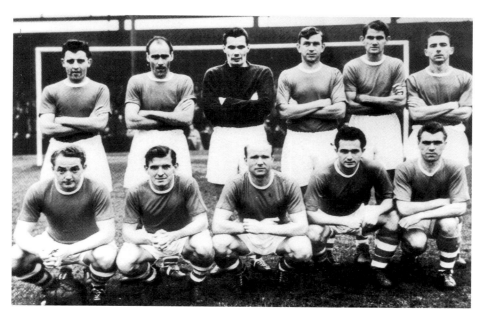

Charlton Athletic, 1956/57. From left to right, back row: Hammond, Campbell, Marsh, Chamberlain, Hewie, Ellis, Gauld, Kiernan, Hurst, Leary, White. Although Charlton had some exceptional players in the team, their performances before and after the sacking of Jimmy Seed were not up to standard, and they were unable to save themselves from relegation at the end of the season.

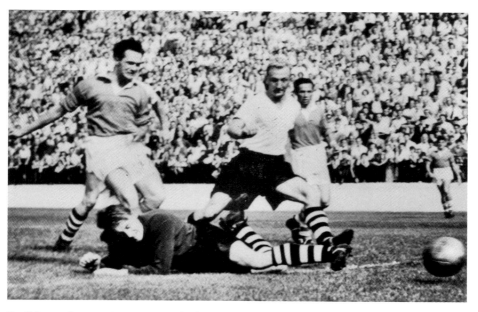

Prolific goalscorer Stuart Leary had a miserable season for his standards, only hitting eight League goals for Charlton. After relegation he was back to form, scoring seventeen goals during the 1957/58 season. At the end of his Charlton career, Leary scored a record 163 League and cup goals for the club.

A programme from the most remarkable match in the history of Charlton Athletic FC, played at The Valley on 21 December 1957. With Christmas only four days away, a modest crowd of only 12,535 were in attendance to witness this amazing football spectacle. Down to ten men in the first half, losing defender Derek Ufton to a dislocated shoulder, Charlton were 2-0 down before the break. Johnnie Summers made it 2-1 after the second half kicked off, then Huddersfield scored three goals in just under fifteen minutes, leaving Charlton trailing 5-1. With twenty-eight minutes left, Summers scored again, followed by another from 'Buck' Ryan. Summers scored three more and Charlton took the lead 6-5. On eighty-six minutes Stan Howard, who was in the Huddersfield side instead of the young rising star Denis Law, scored, and it looked as if the game would finish 6-6. In the final minute Summers put in a cross for 'Buck' Ryan to score the winning goal, and this extraordinary game finished 7-6 to Charlton Athletic. The match was chosen by *The Observer* in 2001 as one of the ten greatest sporting comebacks of all time, the only football representative on the list.

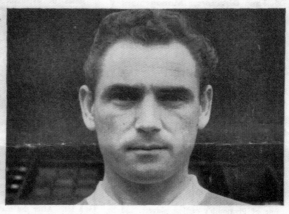

(" Kentish Independent " photograph by Pace of Sidcup)

JOHNNY SUMMERS

MENTION of Johnny always brings to mind his amazing feat in scoring five second half goals in that still more amazing match with Huddersfield at The Valley three years ago. But then, his soccer career is wrapped up in goals. Since he joined the club from Millwall in November 1956, he has been Charlton's top scorer, totalling nearly a hundred League and Cup goals.

A Londoner who learned the elementaries of football while at school at Hammersmith, Johnny joined Fulham when only 16 years of age and made his League debut for them on the same day that Derek Ufton first played for Charlton. He was transferred to Norwich in 1950, and then to Millwall in 1954. For Charlton, Johnny has occupied all the forward positions with the exception of outside-right.

Naturally, goalgetters quickly arrive at a pretty accurate assessment of defenders they are up against, and Johnny regards Joe Shaw (Sheffield United) and Ken Thomson (Middlesbrough) as two of the toughest he has faced. For a man 33 years of age, Summers has remarkable speed, stamina and shooting power.

What of the future? " I cross my bridges as I come to them "—was Johnny's guarded reply. He hopes to continue playing for a long time yet. As a printing trade worker, he keeps his " card " fully paid up, against the day when he can no longer play. Johnny is married, lives at Catford, and has a son—John.

Charlton programme featuring Johnnie Summers, five-goal hero in the 7-6 win over Huddersfield Town, who scored two in a 6-4 win over Plymouth Argyle on Boxing Day, 1960. Two months before, Summers had scored five goals in a 7-4 victory over Portsmouth. During his five seasons with the Addicks, Summers scored 104 League and cup goals before his career was tragically cut short when diagnosed with cancer. He died from the illness at thirty-four years of age.

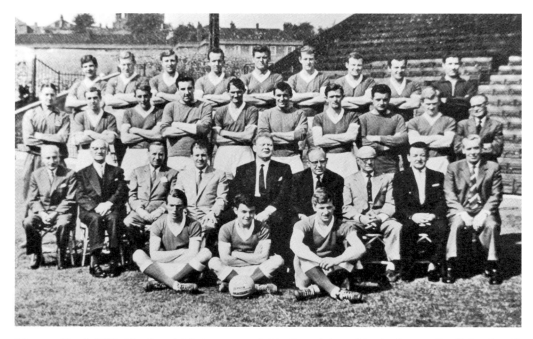

Manager Frank Hill's Charlton Athletic team, 1962/63. From left to right, back row: Cordjohn, Sewell, Bailey, Lucas, Kinsey, Matthews, Kennedy, Lawrie, Hall (assistant trainer). Middle row: Basford (trainer) Hinton, Henderson, Reed, Hewie, Wakeman, Tocknell, Duff, Ord, Myton (maintenance). Seated: Phillips (secretary), Wilkinson (director), Edmonds (director), D. Gliksten (director), M. Gliksten (chairman), Law (director) Clark (director), Hill (manager), Robinson. Front row: Glover, Peacock, Miller. In Hill's first full season in charge, Charlton saved themselves from relegation on the last day of the season, beating Walsall away 2-1, and sending the Saddlers down in their place.

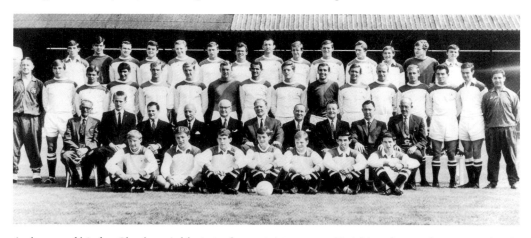

A change of kit for Charlton Athletic in the 1964/65 season. Finishing the previous campaign in fourth place, although thirteen points behind the second-place promotion position, expectations were high that Charlton could do better this season. Although Eddie Firmani, who had returned to the club the previous year, finished top scorer with sixteen goals, the team's performances were poor, and as the crowds began to fall away towards the season's end, so did Charlton's position in the division, finishing in eighteenth place, two points off relegation.

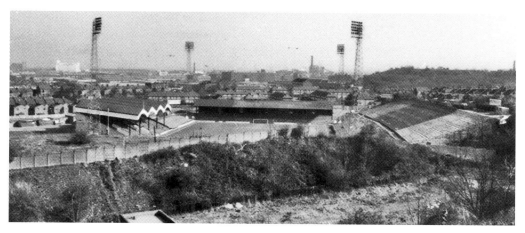

The home of Charlton Athletic, viewed from a high area behind the south end. This is how I remember The Valley when I attended my first match back in the mid-1960s. The 120-foot-tall pylon floodlights were a recent addition, used for the first time against Rotherham United in a midweek match on 20 September 1961.

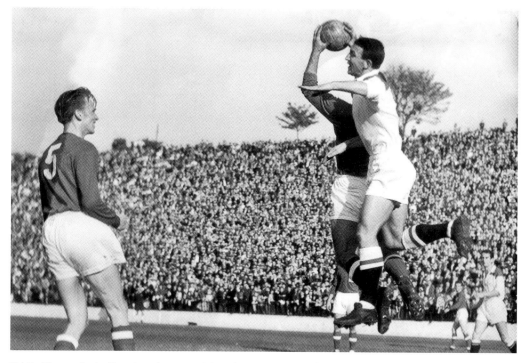

Eddie Firmani, challenging the opposition 'keeper, returned to Charlton after spending eight years in Italy playing for Sampdoria, Internazionale and Genoa. Before he left, for a British record fee of £35,000, Firmani scored fifty-one League goals in 100 appearances and thirty-two League goals in sixty-one appearances on his return. The South African born Italian international, although then in his early thirties, was still scoring an average of a goal every two games, and he was sold before the end of the 1964/65 season.

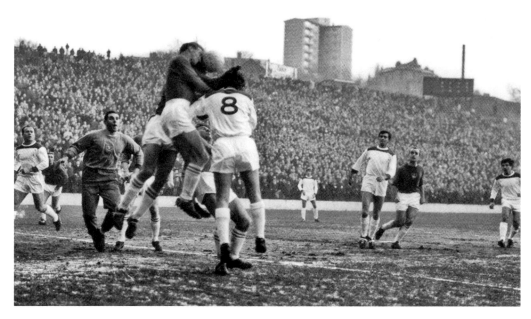

Charlton take on Portsmouth in a 2-2 draw at The Valley on 27 December 1965. Ron Saunders (far left) looks on, as Charlton's forward Roy Matthews challenges for a high ball. After the selling of Firmani, the board then decided not to renew the contract of manager Frank Hill, who was replaced by Bob Stokoe.

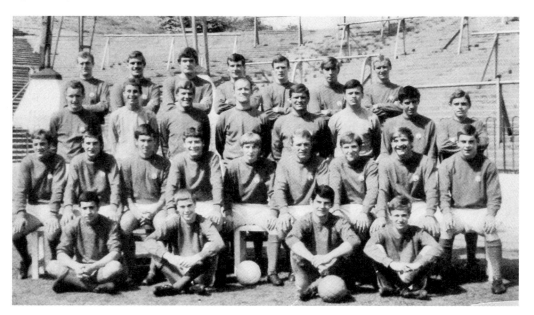

Eddie Firmani returned to Charlton as a player in March 1967, and six months later took over the managerial role from Bob Stokoe, after the team made a poor start to the season. Firmani's team (above) did much better, finishing the 1967/68 season in third place, six points behind promotion rivals Crystal Palace.

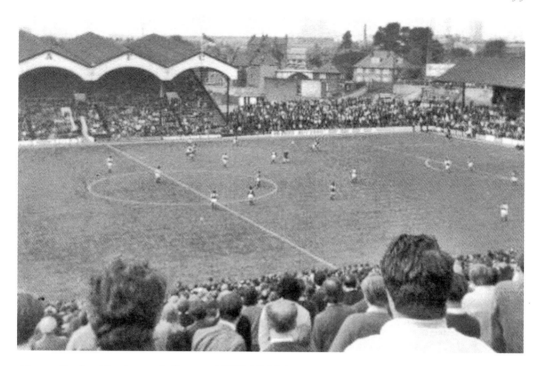

Above: During Charlton's challenge
for promotion, attendances at The
Valley increased to an average of
17,973, and the season had been
full of excitement and expectation,
with the terraces full of happy
Charlton Athletic fans.

Right: Harry Gregory, who joined
the club from Leyton Orient in
1966, became an instant hit with
Charlton supporters, where on one
occasion after scoring a goal he ran
off the pitch, jumped up onto the
low wall surrounding the pitch, and
fell forwards into the outstretched
arms of the cheering fans. For
young Charlton supporters like
my friends and I, Harry was our
Charlton footballing superstar of
the day. He would wear his football
shirt out over the top of his shorts
in the fashion of George Best, unless
told to tuck it in by the referee, and
if his shirt had a collar he would
probably have worn it raised up,
Cantona style.

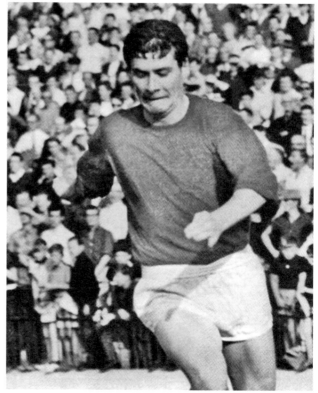

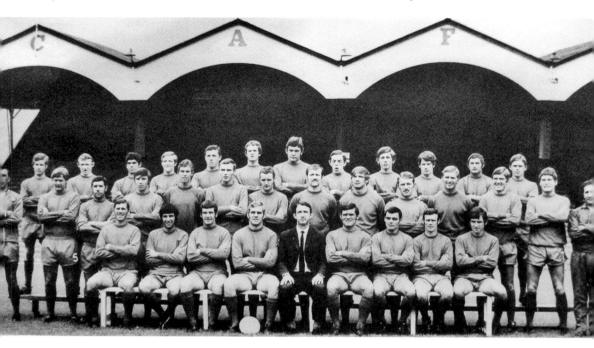

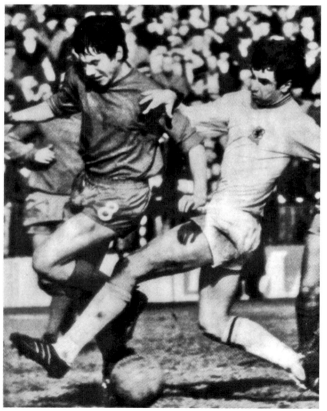

Above: All red for the 1969/70 season. This smart new Charlton kit of red shirts, shorts and socks sold well in the local sports shops, bought by schoolboys to wear during their games lessons; showing support for Charlton Athletic in expectation of another successful season, perhaps even promotion. However, at the end of the season Charlton were perilously close to going down instead of up, managing only one win since just before Christmas. In the last game of the season, with almost 16,000 in attendance at The Valley, Charlton beat Bristol City 2-1, which kept them safe from relegation.

Left: Republic of Ireland international Ray Treacy taking on Aston Villa's Brian Tyler at The Valley on 14 March 1970, where Charlton won 1-0. Besides the last game of the season, this was Charlton's only other win in the latter half of the 1969/70 campaign.

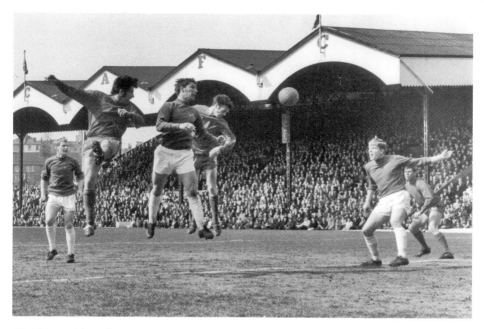

Charlton Athletic forward Matt Tees heads goalwards in a match at The Valley in August 1969, with midfielder Alan Campbell to the left and Ray Crawford far right. Although Tees had been Charlton's top goalscorer the season before with fifteen League goals, he was sold to Luton Town six matches into the 1969/70 season.

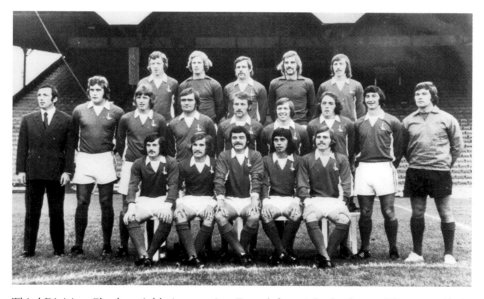

Third Division Charlton Athletic, 1972/73. From left to right, back row: Flanagan, Clark, Jones, Dunn, Curtis. Middle row: Foley (manager), Shipperley, Plumb, B. Hunt, Reeves, Bond, O'Kane, Horsfield, Murphy (coach). Front row: P. Hunt, Ellis, Peacock, Davies, Warman. Theo Foley, assistant to Firmani, took over the managerial role in April 1970, but with little money available to invest in building a team, Charlton were relegated in 1972.

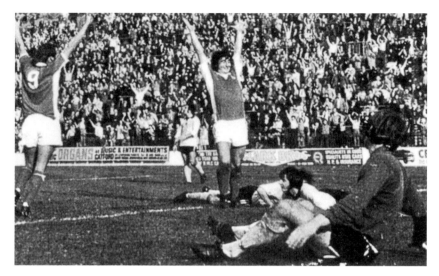

Arthur Horsfield, seen here scoring one of his twenty-five League goals in Charlton's first season down in the Third Division, was brought in by Foley from Swindon Town in return for Ray Tracey and £20,000, a shrewd piece of football transfer market dealing.

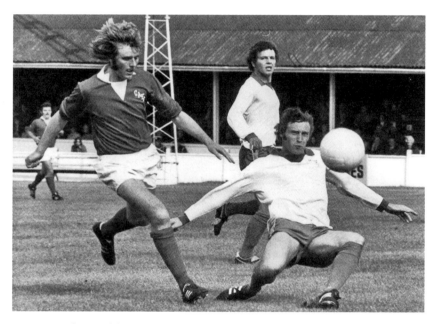

Winger Colin 'Paddy' Powell, another Foley signing in 1973, had first been recommended to Charlton eight years earlier at the age of seventeen by scout Charlie Revell. However, his advice was not acted upon, and Charlton missed out on the services of this exciting player. After eventually signing for Charlton he teamed up well with whichever forwards he played alongside, making goals from his left-wing crosses, and winning plenty of penalties – brought down after making skilful runs into the box.

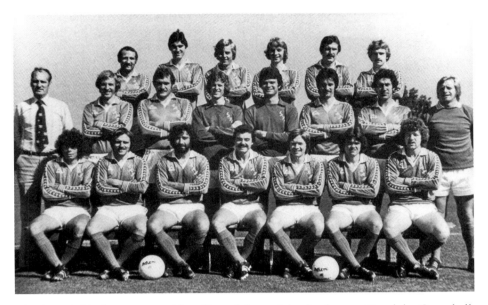

Charlton Athletic team, 1978/79. From left to right, back row: Dugdale, Campbell, Powell, Gritt, Madden, Burman. Middle row: Nelson (manager), Tydeman, Shipperley, Wood, Chalk, Berry, Shaw, Cripps (assistant manager). Front row: Penfold, Warman, Hales, Peacock, Brisley, Robinson, Flanagan. Under manager Andy Nelson, Charlton won promotion in 1975, with several of Foley's signings taking the headlines, including Arthur Horsfield, Colin Powell, Mike Flanagan and Derek Hales, who between them scored forty-one League goals that season.

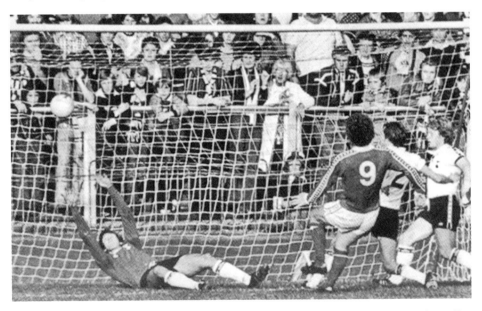

Mike Flanagan scoring the last goal of his hat-trick in a 4-1 win over Spurs at The Valley on 15 October 1977. 'Flash', as he was known by the fans, hit 120 League and cup goals during his time with Charlton.

5

THE VALLEY DEPARTURE

Immediately after coming into the club, Alan Mullery started making changes to the playing staff, bringing in six new players before the season began. At around the same time, another new face came into The Valley; not a player but local businessman and Charlton supporter Mark Hulyer, who was making a financial investment in the club. At that time my friends and I were not concerned about the goings-on behind the scenes at the club, and like a majority of Charlton supporters we were all unaware, and unconcerned, about where this Kent-based entrepreneur would be leading the club. Alan Mullery's new team lost just one match in the first XI played, but then went on to lose five in a row, which set the pattern for the remainder of the season, with Charlton eventually finishing in thirteenth place. For the club's first season back in the Second Division, the final position should not have been unexpected by the Charlton supporters, but attendances began to drop away after the team's performances had faltered towards the end of the season. The businessman from Kent became much more involved in the club affairs during the season, which resulted in the Gliksten associations with the club coming to an end – or so we thought – which did not go down well with the Charlton manager. When Hulyer became club chairman, Alan Mullery resigned.

Hulyer brought Danish star forward and twice European Footballer of the Year Allan Simonsen into the club and, although gate receipts increased during the extremely short period of time Simonsen wore the red shirt of Charlton Athletic, the club was now in serious financial difficulties. When interim manager Ken Graggs was sacked, reserve-team coach Lennie Lawrence took over as caretaker manager, and in an attempt to balance the books, the board of directors made the decision to sell two of the clubs most promising young local home-grown players Paul Walsh and Paul Elliott.

The following season, with the club's financial crises deepening, former club chairman Michael Gliksten took Mark Hulyer to court, over a debt Gliksten claimed he was owed, lodging a bankruptcy order against him. Then came a proposal to sell the ground for redevelopment, before Leeds United sought a winding-up order for debts Charlton owed over a transfer deal. While all this had been going on, Lennie Lawrence was trying to keep the club moving forward on the playing front. However, at the end of the 1982/83 season, Charlton found themselves four points off relegation, finishing in seventeenth place. Throughout the next two seasons, Charlton faced one financial crisis after another,

from a demand by Michael Gliksten's company for rent arrears owed on The Valley to tax arrears owed to the Inland Revenue. Charlton Athletic were faced with the real possibility of going out of business, until Mark Hulyer finally made the decision to quit the club, giving property developer Sunley the opportunity to step in to rescue the club. As Charlton went into the 1985/86 season, the club's financial crisis seemed to have been resolved.

When supporters entered through the turnstiles at The Valley for Charlton's sixth game of the season against Crystal Palace, we were all handed a single sheet of A4 paper announcing that Charlton would be leaving The Valley to groundshare with our opponents. The only positive outcome that day came through beating our prospective landlords 3-1. The Charlton board had given their reasons why there was a need to move the club out of The Valley, none of which the supporters believed were good enough reasons to take such a drastic measures. Against all the supporters' protests, the move went ahead.

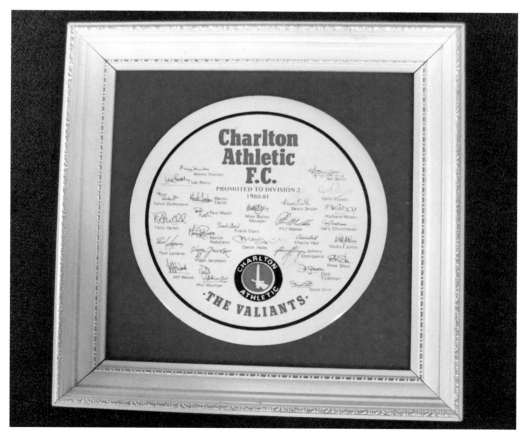

A souvenir plaque, celebrating Charlton's promotion back into the Second Division at the end of the 1980/81 season, signed by the players and manager Mike Bailey.

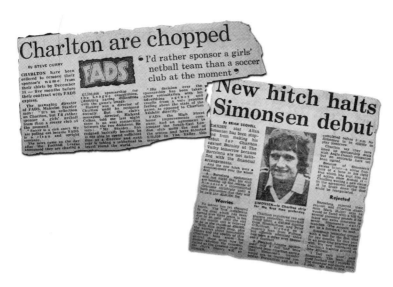

Financial crises at Charlton Athletic and the club makes headlines for all the wrong reasons. With debts of over £600,000, and a loss in excess of £500,000, Charlton Athletic were in serious financial difficulties. These were added to by the signing of Danish international star Allan Simonsen for £324,000, initiated by new club chairman Mark Hulyer.

Allan Simonsen, 1977 European Footballer of the Year, eventually made his debut for Charlton in a reserve match at The Valley against Swansea on 10 November 1982, watched by over 2,000 fans. One of the most skilful players to have worn a Charlton shirt, his time with the club was brief. Playing in only seventeen League and cup games, scoring nine goals, he was off back to Europe on a free transfer – part of the deal struck by Hulyer if he could not guarantee keeping him on at the season's end.

Ronnie Moore and Mike Flanagan in front of the East Terrace during a match at The Valley in the 1984/85 season. This vast expanse of concrete terracing, once accommodating over 30,000 fans alone, had now becoming sparsely populated, and as the club's fortunes on the pitch fell away, so did attendances, with the average home gate falling to 6,732.

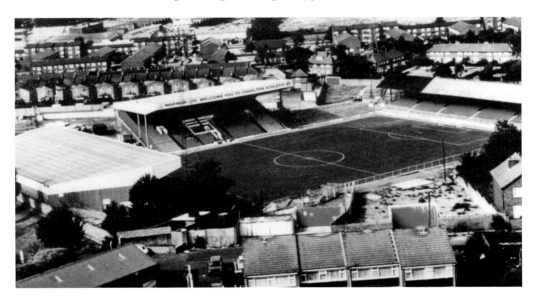

The Valley after major improvements had taken place in the early 1980s, financed through a lottery which raised £350,000. The old distinctive multi-span roof of the West Stand was replaced with a modern structure, seats were installed in the covered end, and a new modern all-seater stand erected on South Bank, officially named 'The Jimmy Seed Stand' when opened in 1981. However, no work took place on the old East Terrace.

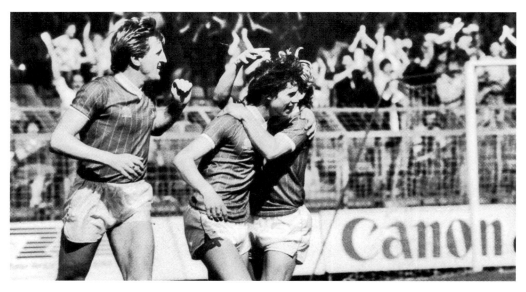

Robert Lee being congratulated after scoring one of his two goals in a 2-1 win over Portsmouth at The Valley on 21 April 1984. Shirt sponsorless and deep in financial trouble, Charlton may well have gone out of existence just over a month before if the Sunley Group had not come into the club with a financial rescue package to allow them to continue for the remainder of the season.

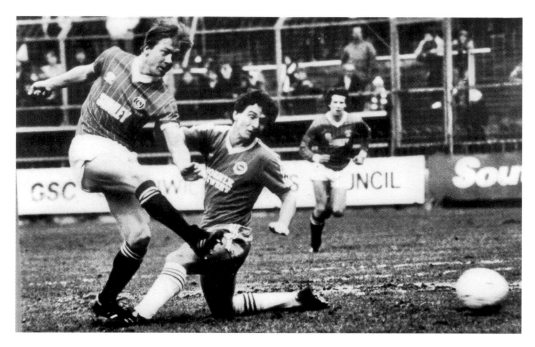

New signing Alan Curbishley, with the club saviours' logo emblazoned across his shirt, fires in a shot at the Brighton & Hove Albion goal on 1 January 1985. The midfielder, signed from Aston Villa, brought a touch of class to the team, although his major achievements with Charlton would come as manager thirteen years later.

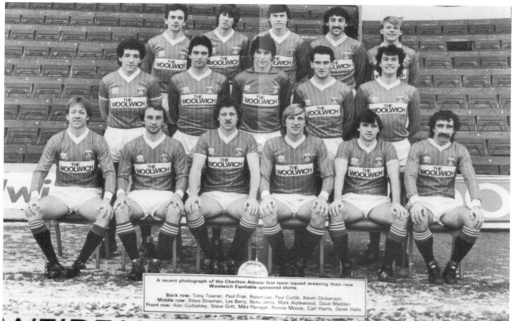

Programme announcement featuring the 1984/85 team wearing the new shirts sponsored by the building society Woolwich, after investing £50,000 in the club through a two-year shirt and promotional deal.

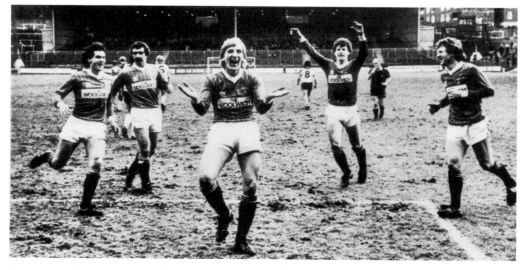

A fantastic Charlton forward line in a very empty Valley for a match against Barnsley on 2 March 1985. A diminutive crowd of 3,832 were in attendance when Charlton came back from 3-1 down to win the match 5-3. From left to right: Dave Madden, Derek Hales, Ronnie Moore, Robert Lee, Mike Flanagan. The scorers on the day were Dowman (2), Lee, Flanagan and Moore.

MESSAGE TO OUR SUPPORTERS

It is with regret that we must announce that we will be obliged to leave The Valley the home of Charlton Athletic Football Club for 66 years.

Recent events have forced this unhappy decision upon us. On 1st July the owners of the land behind the West Stand gave notice terminating our right to use or occupy the land. Court proceedings were commenced to evict and we have been obliged to agree to go by the end of September.

On 6th August 1984, the Greenwich Magistrates ordered that the East Terrace be closed as work was required to the concrete steps and crush barriers. We were not informed of defects to the crush barriers when we were given an opportunity to take a lease of The Valley literally two hours before we appeared before the High Court Judge in March 1984 to obtain consent for the arrangements to save the Club.

The facilities at The Valley for the safe and orderly entrance and segregation of fans and accommodation for spectators and car parking have been so drastically curtailed by the effect of the two sets of court proceedings that we have had no alternative but to make other arrangements.

With effect from 5th October, the home matches of Charlton Athletic Football Club will be held at Selhurst Park which will be in future home for both Charlton and Crystal Palace who will keep their separate identities. We are delighted with this arrangement and the big welcome Crystal Palace Directors are giving us.

HOW TO GET THERE

BY BUS

No. 75. From Charlton Village to Selhurst/Norwood Junction (every fifteen minutes) — journey 50 minutes.

BY TRAIN

Charlton to Norwood Junction.
Change at London Bridge.
Charlton to London Bridge 2 trains every hour journey time 14 minutes.
London Bridge to Norwood Junction 3 trains every hour journey time 20 minutes.

The shaded part of the drawing below shows the land we cannot use as from 30th September 1985.

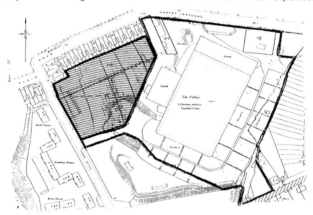

In the crisis we endeavoured to find a home in the London Borough of Greenwich, but although the Council was most helpful, to find even merely adequate facilities was impossible. Our players will continue to train locally at Charlton Park and our South Eastern Counties League matches will continue to be played at Meridan Sports Ground. It is still uncertain where we will play our home Football Combination Matches. It is our firm intention to make Charlton Athletic a First Division Club and we are delighted with such a good start to the season. Our big worry is the inconvenience which will affect you, our supporters, practically and emotionally. Like most of you I have been a supporter of Charlton Athletic for many, many years and feel very sad indeed at the prospect of football no longer being played at The "Valley", but delighted with our prospects at Selhurst Park.

We wanted you, our supporters to be the first to know. To help supporters who find it impossible to get to Selhurst Park we are prepared in the interim to provide a number of coaches. Please contact the Secretary if you wish to travel this way.

Season Ticket Holders will be offered the best seats in the house, with enormous regret, a refund, if they do not wish or cannot carry on supporting Charlton Athletic. We expect to be able to make special discount arrangements for people who wish to watch both Charlton and Crystal Palace first team games. A letter will be sent out soon to all season ticket holders.

Some compensation is that facilities at Selhurst Park are superior to those at "The Valley" and the playing field is in first class condition too.

Lets give the lads a bigger cheer this afternoon and encourage them to provide a result to take us nearer Division One.

JOHN FRYER

The announcement handed out to supporters at the turnstiles on their arrival at The Valley for a match against the club's new groundshare landlords Crystal Palace, 7 September 1985. Although Charlton beat Palace 3-1, the fans were incensed by the outrageous decision to move the club from The Valley and away from SE7.

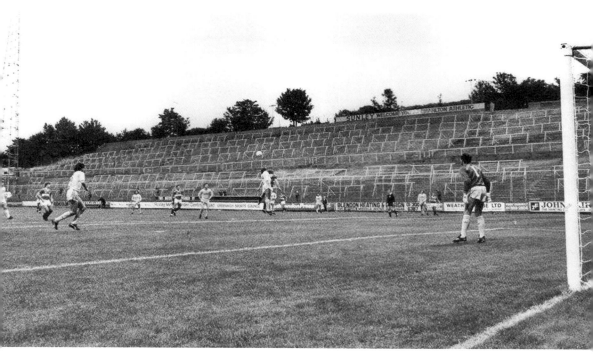

Above: An empty East Terrace, not deserted by fans, but closed down by the Greater London Council (GLC). Prior to the start of the 1985/86 season, the GLC took out a summons, citing the Safety of Sports Ground Act, to stop the use of the terrace due to safety repairs not being carried out as required in 1979. With the ground owner Michael Gliksten apparently claiming he was going to use over 2 acres of land to the rear of The Valley car park to build houses upon, the club's new chairman and managing director of Sunley, John Fryer, made the impromptu decision to find Charlton a new ground.

Right: Michael Gliksten makes an appeal in the local papers for understanding, in reply to the statement made by John Fryer in the leaflet handed out to supporters, which laid blame for the move firmly at his door. Gliksten claims that to reduce the rent on The Valley, the new board gave up use of this piece of land willingly. For Charlton supporters stuck in the middle, none of us knew who to believe, nor the real motives why the board of directors were pushing through the move without any consultation with the supporters, and there was a real fear that after the move Crystal Palace and Charlton would merge, which may have become reality if truth be known.

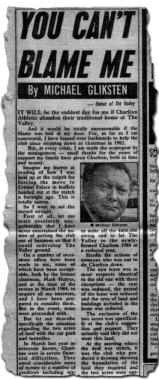

YOU CAN'T BLAME ME

By MICHAEL GLIKSTEN

— *Owner of The Valley*

A Crystal Palace programme, 7 September 1985, for the match when the announcement was made that Charlton would groundshare with their opponents of the day, and a souvenir edition for the last match at The Valley against Stoke City, 21 September 1985, containing editorial reminiscing on the history of The Valley and momentous occasions and matches that had once taken place at the home of Charlton Athletic. Rubbing salt into an open wound comes to mind.

Sports columnist and devoted Charlton Athletic fan Patrick Collins wrote a moving 'obituary' in remembrance of his club in the *Mail on Sunday*, 22 September 1985, issued the day after the last match played at The Valley.

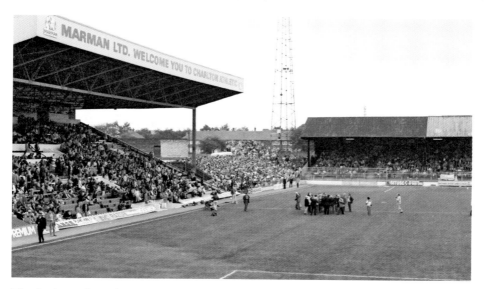

The final match at The Valley, 21 September 1985. A troop of former players were paraded out onto the pitch prior to kick-off in an attempt by the Charlton Athletic board of directors to turn this sombre occasion into a day of celebration. However, Charlton fans had other ideas, laying red and white wreaths on the pitch, and then staging a second-half sit-down on the centre circle, with one brave soul climbing to the heights of the north-west corner floodlight pylon to wave a fist of defiance towards the Charlton directors. Named as idiots by Chairman John Fryer, the fan's protests were completely justified.

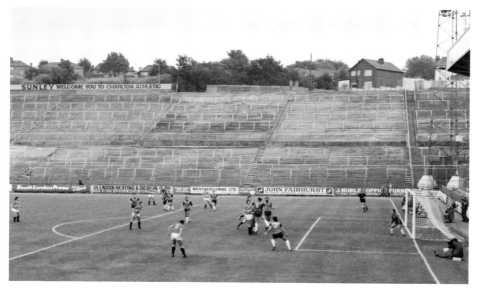

Charlton players attacking the Stoke goal at the south end of The Valley in the first half of the match. The vast East Terrace, absent of spectators apart from two lonely stewards standing at the top, had been closed off at the start of the season when Liverpool made a visit for a friendly. Charlton beat Stoke 2-0 in front of 8,885 fans, with a goal from Mark Stuart in the seventy-third minute, and one from Robert Lee in the eighty-third minute – the last goal scored at The Valley.

BACK HOME

The 10-mile journey from SE7 to South Norwood could take you just over an hour on a busy Saturday afternoon, travelling either by bus, car or train, and after Charlton had moved to groundshare with Crystal Palace, supporters found various and varied routes across the south of London, to make their way to Selhurst Park for the remainder on the 1985/86 season. I was one of many supporters who decided not to attend home games at Selhurst Park while Charlton were in exile. Playing in front of small crowds, Lennie Lawrence, with hardly any substantial funds to invest in the team, against all odds, won promotion to the First Division.

After the directors had first made the announcement that Charlton would groundshare with Crystal Palace, a dedicated group of Charlton supporters began to organise protests against the move. At a volatile meeting held at The Valley Club in October 1986, the directors were presented with a petition, signed by 10,000 fans, supporting a return to The Valley. While there was still no sign of a return, I carried on with my own campaign of refusing to travel to Selhurst Park, in the belief that if enough Charlton supporters boycotted home matches, which many were doing, the directors may realise the error of their ways, and bring the club back home.

By June 1988, the ownership of Charlton Athletic had changed once more, with Roger Alwen and Mike Norris, two men who shared the same views as the campaigning supporters that there was no future for Charlton Athletic groundsharing with Crystal Palace, taking full control of the club. While the team battled valiantly to stay in the top division, plans were underway for the club's return to The Valley.

The new board of directors soon found that they had another battle on their hands, this time with the local council, who were not in favour of Charlton Athletic returning to The Valley. The Charlton supporters then came to the club's aid by forming The Valley Party, with the aim of fighting the council at the local elections, launching their own political campaign, 'Vote Valley', to persuade the people of the borough to lend their support to the cause. At the local elections The Valley Party received the backing of the people, securing a massive 14,838 votes.

While all this had been going on in south-east London, further west in the borough of Croydon, Charlton Athletic carried on their fight to remain in the First Division. In the first two seasons back in the top flight, Charlton could finish no higher than fifth

from bottom, and only kept their status through a series of convoluted play-off matches. However, Charlton made their first visit to Wembley for over forty years, reaching the Full Members Cup final in March 1987. Lennie Lawrence kept Charlton in the top division for a further four seasons, playing against the best clubs in the English Football League.

After confirmation from the new board of directors that Charlton would be making a return to The Valley, I then began attending matches at Selhurst Park, and purchased a season ticket for the first time ever too. However, before Charlton Athletic made their exit from Selhurst Park, at the end of the 1989/90 season, the club also made their exit from the First Division, finishing second from bottom, one place above Millwall. As a Charlton supporter you have to be an optimistic pessimist, where in your heart you hope life in the First Division will never end, but in your head you know that relegation is more likely. It was an extremely disappointing end to the 1998/90 season, knowing that we would be returning to The Valley as a Second Division team.

Although I had missed a majority of Charlton's home matches in the First Division while playing at Selhurst Park, my friends and I were now confident that, as Charlton had won promotion into the top division under the management of Lennie Lawrence, there was no reason why he could not do it again – but this time we would be playing First Division games at The Valley. The following year, however, Charlton were still playing at Selhurst Park, finishing the season in sixteenth place, which is not what we had all expected. Then, after Lennie Lawrence resigned to take up the manager's position at First Division Middlesbrough, the Charlton board unexpectedly offered Alan Curbishley and Steve Gritt the role of joint first-team coaches.

There was the inevitable doubt on the worthiness of appointing two players to what, in effect, would be a managerial partnership; however, Alan Curbishley and Steve Gritt took the team to one place off the Second Division play-off places in their first season in charge. Playing temporarily at Upton Park, attendances were no better than when playing at Selhurst Park, and to ensure Charlton remained financially stable, it was essential that the move back home to The Valley came sooner rather than later. After the formation of the FA Premiership, the League divisions were reclassified and Charlton began the 1992/93 season playing First Division football. During the close season it had been full speed ahead to get The Valley ready for football once more, but we would have to endure just over another three more months playing in the East End before that day arrived. Charlton went on a ten-match unbeaten run, and in a 1-0 away win over West Ham, the attendance at Upton Park totalled 17,054. Although an away fixture, this was the largest gate Charlton played in front of while resident at Upton Park, as Charlton would soon be leaving the land of cockles and winkles behind, to return south of the river.

With the huge East Terrace still out of use, and ground capacity limited to just 8,337, the match was a sell-out for Charlton's triumphant return to The Valley on 5 December 1992. The opposition on that historic day were Portsmouth, who Charlton had played more times than any other club in the Football League, and on that memorable day I watched the game from the Jimmy Seed Stand, in a seat very close to where I had been sitting during the club's last match at The Valley seven years before. Then, seven minutes into the game, Colin Walsh latched onto a through ball from Darren Pitcher, to strike a low left-footed drive past the Pompey 'keeper and into the back of the net. At the final whistle Charlton had won the match 1-0, and their future was secure.

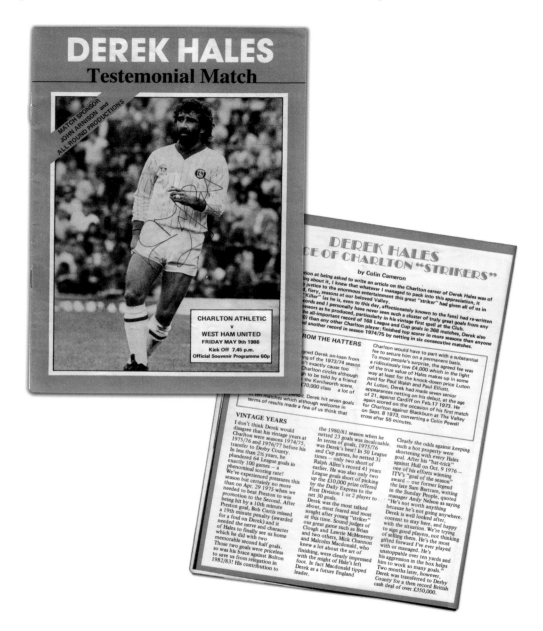

Record club goalscorer Derek Hales had been released on a free transfer in March 1985 to move to Gillingham. After two periods with the club spanning twelve years, he was rightly expecting a testimonial to be played at The Valley. The match, however, was played at Selhurst Park after the move, which, understandably, Hales was not pleased about. This was one match I did attend in the club's first season at Selhurst. West Ham United were the opposition, Hales' previous club before returning to Charlton, where 'Killer', as he was affectionately known by the Charlton supporters, scored in the 5-3 win. A gate of just 2,000 hardly befitted a player who served the club so well, scoring 168 League and cup goals for Charlton.

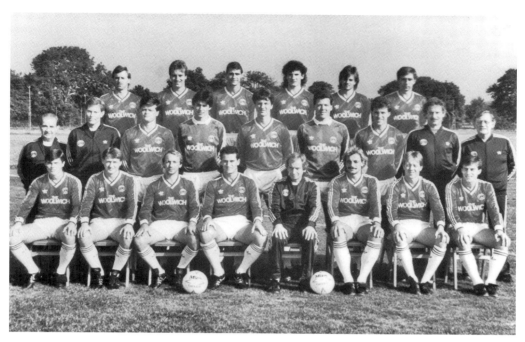

Above: Charlton back in the First Division, 1986/87. Unbelievably, manager Lennie Lawrence and his team, playing home games at Selhurst Park, won promotion, playing to an average gate of just 6,068 at Selhurst Park. Although this would increase to 9,012 in the First Division, this only bettered average attendances at Luton Town, Oxford United and Wimbledon.

Right: Coming back from 2-0 down to win 3-2 at Carlisle United, Charlton gained promotion to the First Division twenty-nine years after they were relegated in 1957. Promotion into the top division was something we all thought we would never live to see, and now Charlton would be playing against the likes of Liverpool, Manchester United, Arsenal and Chelsea not at The Valley but at Selhurst Park, a travesty of justice.

A trip to Selhurst Park in March 1987 to purchase tickets to the Full Members Cup final, a competition formed after the Hysel Stadium disaster, when English clubs were banned from all UEFA competitions. After knocking out Birmingham, Bradford, Everton and then Norwich, Charlton would be up against Blackburn Rovers in the Wembley final.

Charlton enjoy a goal spree

By a Correspondent

Charlton 5
Manchester City 0

Three goals of genuine class and two of sheer opportunism pushed Charlton off the bottom of the table, overwhelming a lacklustre Manchester City side 5-0 at Selhurst Park yesterday, in the south London side's best win since returning to division one this season.

This encounter did not bode well as a footballing classic. Charlton had gone nine games without a league win, and City have not won away since January 18. The opening minutes typified the plight of both sides. The football was fast and furious, lacking thought and direction.

Alan Curbishley, Charlton's midfield player, who has been missing from their line-up for most of the season through injury, added some calming touches, though his team mates were often on a different wavelength. For their part, City offered very little in the way of flair or imagination, and looked a sorry sight.

Charlton took a deserved lead with a cracking first goal by Colin Walsh in the 25th minute. Walsh, out wide on the left side of the penalty area, was teasing John Gidman, City's right back, who like everybody else expected a cross. Walsh, however, unleashed an unstoppable left-foot drive that rebounded off the post and into the net.

After half-time Charlton thundered on, dismissing any doubts that the added pressure of starting the game at the foot of the table would affect them. Two minutes after the half-time interval Walsh added a second with a rasping 20-yard free kick.

Jim Melrose scored a fine third goal on the hour, a right-footed curling shot that dipped into the net at the far post. Then, Charlton's central defender, Peter Shirtliff, not one to be left out, seized upon a loose ball in the six-yard box to make it four. George Shipley completed City's humiliation with a fifth goal, slipping in to convert from four yards in the 82nd minute.

CHARLTON: R Bolder, J Humphrey, M Reid, G Shipley, A Peake, P Shirtliff, M Stuart (sub: J Pearson), A Curbishley, J Melrose, M Aizlewood, C Walsh.

MANCHESTER CITY: P Suckling, J Gidman, C Wilson, K Clements, N Reid, S Redmond, D White, N McNab, I Varadi, P Moulden, P Simpson.

Referee: P W Vanes.

● Mark Hughes scored his first league goal in more than two months to keep Barcelona on top of the Spanish league with a 1-0 win in Cadiz yesterday.

Although playing in the First Division was a tough experience for the Charlton team, there were some memorable matches, with away wins against Manchester United 1-0, Newcastle United 3-0, West Ham United 3-1 and Chelsea 1-0. While at home there were wins over Aston Villa 3-0, Everton 3-2 and Manchester City 5-0, the best home result of the season.

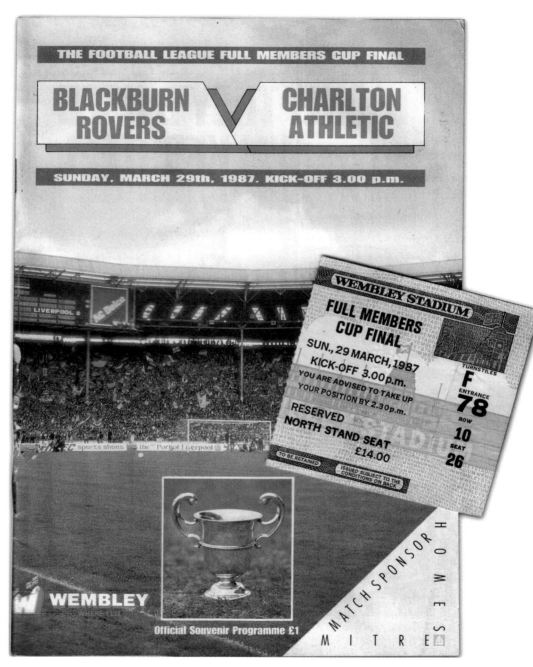

Charlton Athletic made their fifth appearance at Wembley on 20 March 1987, another milestone in the club's history. Although this was not a prestigious competition, for Charlton supporters a trip to Wembley to watch Charlton play in any final, with the prospect of winning silverware, would be a fantastic experience.

The teams walk out onto the pitch in front of 43,789 supporters: not a big crowd for a Wembley final, but it was the largest turnout of Charlton supporters for many years. The only disappointment of the day would be the final score – 1-0 to Second Division Blackburn Rovers, with Colin Hendry scoring the winner five minutes before full-time.

On our return, celebrating a day out at Wembley, if not the result, in the Victoria, Greenwich. As Charlton supporters, days like these were few and far between, and when they did come around we would all make the most of them.

THE TODAY FOOTBALL LEAGUE

**PLAY-OFF FINAL
FOR FIRST DIVISION PLACE – REPLAY**

CHARLTON
v
LEEDS

PLAYED AT
THE HOME OF
BIRMINGHAM CITY F.C.
ST. ANDREW'S GROUND
BIRMINGHAM
FRIDAY
29th MAY
1987

★ Official
Programme
Price: 40p

Charlton Athletic survive a play-off final replay against Second Division Leeds United, at neutral ground St Andrews, 29 May 1987. In a home and away final play-off, the team winning on aggregate would either remain in Division One, or be replaced by the Second Division team. Both Charlton and Leeds won their home ties 1-0. In the replay, with the score 0-0 after ninety minutes, Leeds went one up in the first period of extra time. Then, with only seven minutes left, defender Peter Shirtliff scored twice, and Charlton retained their status in the First Division.

Left: While Charlton Athletic battled to stay in Division One, Charlton supporters had their own battle on their hands in endeavouring to get the club back to The Valley. One supporter, Rick Everitt, founded *Voice of The Valley* in 1988, a fanzine that supported the campaign to bring the club home. Issue nineteen featured the latest news on the The Valley Party, formed to fight the council in the local elections, after the planning committee had blocked the club's return to The Valley.

Below: Charlton Athletic go to Old Trafford on 5 May 1990, already relegated three weeks before, for their last match in the First Division, losing 1-0 to Manchester United.

When Lennie Lawrence resigned in 1991, there was a vacancy for a new manager. However, instead of appointing one, Charlton took on two – Steve Gritt, who was still playing, and Alan Curbishley, player-coach under Lawrence. The joint appointment had come as a complete surprise for the supporters and the media.

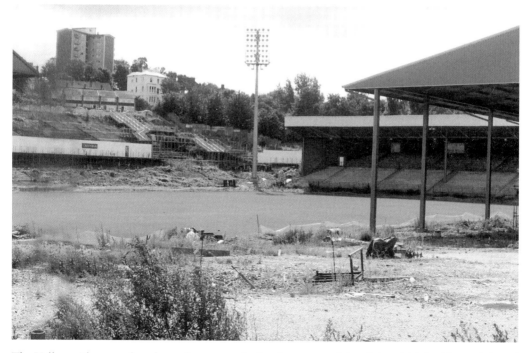

The Valley with groundworks underway ready for the return of the club, which had been deferred in favour of a temporary relocation to Upton Park at the beginning of the 1991/92 season.

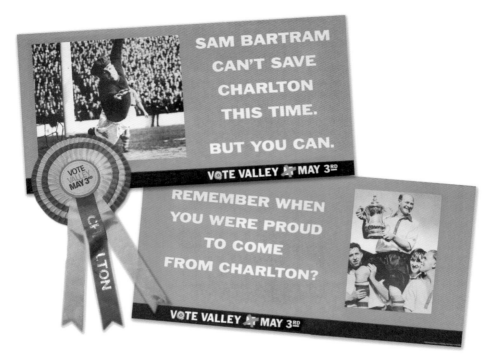

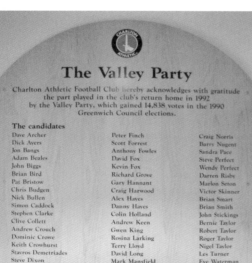

Above: The Valley Party campaign, 1990. The impressive poster display, exhibited around the Borough of Greenwich, had been devised by Richard Hunt, director of advertising agency BMP DDB Needham, appealing to the local populace to vote for The Valley Party members, who were taking on the council in the local ward elections, after a majority of the planning committee had voted against Charlton's application to relocate back to The Valley.

Left: The list of party members on display at The Valley. Although taking 14,843 votes, none of the members won a seat, but such was the strength of support shown, the chairman of the planning committee lost his seat and there was no doubt that Charlton Athletic were wanted back in the borough, not just by supporters, but by the people in the Borough of Greenwich themselves.

A NEW ERA OF FOOTBALL

There may be some truth to support the argument that if Charlton Athletic had not left The Valley, then we, the supporters, may not have had a club to support at all. There is no doubt that the move roused the Charlton faithful from their slumber, where previously there had been real case of lethargy shown towards the club's increasing downward spiral, financially and in League status. The relocation had brought the supporters and a new board of directors together, in a successful rescue attempt to bring Charlton Athletic back to where the club belonged.

After that first game back in December 1992, attendances at The Valley levelled off at around 7,000 during the remainder of the season, and although the club's finances were still not healthy, the time was right for the new Charlton board of directors to show support for the club's management duo by investing in the playing staff and in The Valley, which, to their credit, is what they would go on to do.

European football came to The Valley during the 1993/94 season, through the Anglo-Italian Cup. Although this international competition was looked upon somewhat unfavourably by many 'bigger' clubs, for supporters of clubs like Charlton, this cup tournament gave us all a great opportunity to watch our team play competitive European football.

On the home front, Charlton also reached the quarter-finals of the FA Cup for the first time since 1947, drawing away at Manchester United on 12 March 1994, where over 10,000 Charlton supporters travelled to Old Trafford for the tie.

At the end of the 1994/95 season, Alan Curbishley and Steve Gritt guided Charlton into a play-off place, but lost out to Crystal Palace in the two-leg semi-final. Although the pair had worked well together in the managerial partnership, after director Richard Murray became chairman of Charlton Athletic PLC, he decided to dismiss Steve Gritt and appoint Alan Curbishley as sole manager prior to the start of the following season. There was obvious disappointment among the supporters when Steve Gritt left the club, after serving Charlton Athletic for so long and so well as both player and joint manager. However, we were now fully behind the Charlton chairman and the new board of directors, and trusted in the decisions being made for the benefit of the club.

The ongoing redevelopment of The Valley had increased the ground capacity to almost 15,000, and with attendances continually on the rise, the club's future was looking bright.

During the 1995/96 season Charlton's support increased by one more, when I took my eldest son to a match at The Valley for the very first time. Lee Bowyer and Carl Leaburn scored a goal each to beat Millwall 2-0. Happy days. Later, I would take my younger son and my daughter to matches as well, and when they were older they were all season ticket holders. My eldest son, who was the most enthusiastic Charlton supporter of the three, represented Charlton as their match mascot at Manchester United, Blackburn Rovers and at home to Fulham.

Under manager Alan Curbishley, his assistant Keith Peacock, and first-team coach Les Reed, who joined the club from the FA, Charlton made it to the play-off final at Wembley in 1998, where they were up against promotion favourites Sunderland. In a dramatic final, voted as one of the greatest games ever played at the national stadium, my friends and I saw Charlton, after drawing 4-4 at the end of extra time, beat Sunderland 7-6 on penalties. As 'keeper Saca Ilic dived down to his left to save Sunderland's seventh penalty kick, securing Charlton a place in the Premiership, my friends seated either side began jumping up and down, cheering and shouting for joy. I immediately looked towards the sky, where my thoughts were with my dad, who died four years before, remembering the times he told me about those glorious days from the past when he supported Charlton Athletic as a young boy.

If the play-off final was a dramatic occasion, then Charlton's first season in the Premier League was even more so. My friends and I bought home and away season tickets, to ensure we could be at all Charlton's matches in the Premiership, believing that, in all probability, we would be back in the First Division the season after. Charlton competed in some terrific football encounters throughout that season, and although our beliefs came true, Charlton did not lose their place in the Premiership until the very last day of the season. The players received well-deserved praise for their performances in the top division, undoubtedly becoming a much better and stronger side through the experience, which was proved the following season.

Winning twenty-seven matches out of forty-two, with ten draws and nine losses in the 1999/2000 season, Charlton were promoted as First Division champions before the season's end, in a 1-1 away draw at Blackburn Rovers on 24 April 2000. My son and I celebrated with supporters and players on the pitch at the end of the match.

Charlton were now much better equipped to face the challenge of Premiership football, finishing in a very respectable ninth place, and recording some fantastic results both home and away. Charlton beat Manchester City 4-0 at home in the first game of the season, won 2-0 at Stamford Bridge, and held eventual Premier League champions Manchester United to a dramatic 3-3 draw at The Valley, where my son's favourite player, Johnnie Robinson, came on as a substitute to score the equaliser in the eighty-fifth minute, carrying out one of the most enthusiastic goal celebrations the supporters had seen for many years.

During the following five seasons in the Premiership, Charlton finished no lower than thirteenth place; a fantastic achievement for a club run on a very tight budget, compared to many clubs in the top division. Then, unexpectedly, the board dispensed with the services of Alan Curbishley, after he had refused to sign an extension to his contract, wanting to consider his options at the end of that current campaign.

With Curbishley gone at the end of the 2005/06 season, the directors appointed Ian Dowie as manager, who came to the club accompanied by a writ issued against him by previous employers Crystal Palace. Charlton supporters were somewhat bewildered by the board's belief that Dowie would make a better manager than Curbishley, where one of the reasons the board gave for releasing him from his contract was to enable them to find a manager who could to take the club forward. Although there were many Charlton supporters who believed Curbishley had taken the club as far as he could, there were many more who doubted Dowie would do any better, especially as under his management Palace had been relegated from the Premier League, and had then failed to win the First Division play-off final the season after. However, trusting in the Charlton board, as we had all done in the past, Dowie was left to get on with managing club affairs, and when handed more money to spend in the transfer market than Curbishley had ever been given while in charge, expectations throughout the club were high.

Charlton's results at the start of the season were disastrous, losing eight matches out of the first twelve, and on 13 November 2006, the club and Ian Dowie parted company. Assistant manager Les Reed, who returned to the club to work with Dowie, was appointed manager, but when results did not improve, he left by mutual consent. The supporters' favourite for the managerial vacancy, Alan Pardew, who at the time was between jobs, was appointed manager, but it was much too late to save the sinking ship, and relegation came at the end of the season. Under Pardew, Charlton failed to win promotion straight back – which is what we had all expected – or to at least secure a place in the First Division play-offs. The following season results did not improve, and after Charlton dropped into the bottom three, the supporters began to protest outside of the West Stand, demanding the sacking of Pardew and chanting, 'We want our Charlton back', which indeed we all did.

The club was literally falling apart in front of us; players did not seem to be interested in playing for the club, and the once astute, resolute board of directors, a majority of whom were successful businessmen, were now in disarray. Pardew was sacked and the role of caretaker manager went to his assistant Phil Parkinson, who, despite failing to win any of his first eight games in charge, was then given the job full-time. Relegation followed, and Charlton dropped down into the third tier of the Football League.

Under Parkinson, Charlton made a good start the following season. They eventually finished in a play-off place, but lost out to Swindon Town after an uninspiring semi-final second-leg performance at The Valley, losing miserably in a penalty shoot-out. Never a favourite with the Charlton fans, Parkinson's time was up in January 2011 after the new club owners, deciding he was not the man for the job, replaced him with Chris Powell. An immediate hit with Charlton supporters, Powell won his first four games in charge; they say that players usually put on good performances after a new manager comes into a club. However, this did not last long at Charlton, as the team then went eleven matches without a win. The supporters began to fear the worst, that the former Charlton and England left-back might suffer the same fate as the previous four managers. However, the board kept the faith and the following season Chris Powell guided Charlton to promotion as First Division champions – a fantastic achievement, especially as he had brought in nineteen new players for his first full season in charge.

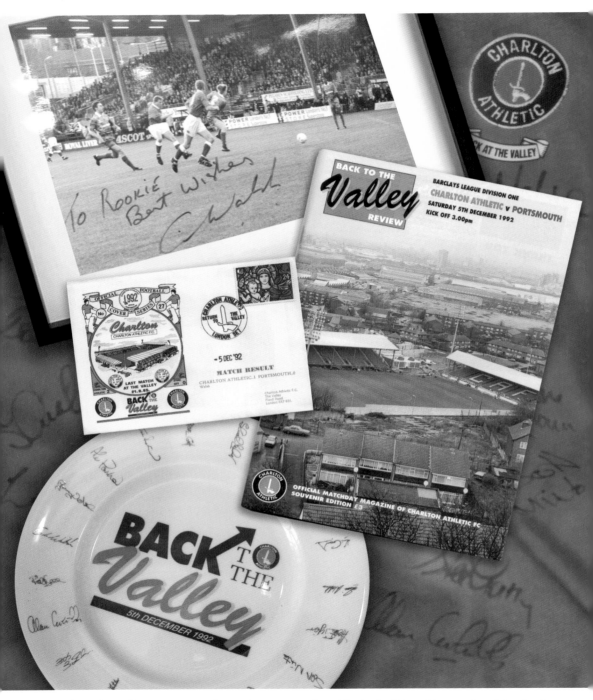

Back to The Valley souvenirs, 5 December 1992: a signed limited edition shirt, produced for the day of the match; the matchday programme; the first-day cover recording the date and result; a plate signed by the Charlton players who took part in the match; and a signed picture of Colin Walsh, scoring that historic goal.

RETURN TO THE VALLEY
Charlton Athletic 1 - Portsmouth 0
5th December 1992
Attendance 8,337

1. Bob Bolder 2. Darren Pitcher 3. Scott Minto 4. Steve Gritt *(Joint Manager)* 5. Simon Webster 6. Stuart Balmer 7. John Robinson 8. Lee Power 9. Carl Leaburn 10. Garry Nelson 11. Colin Walsh.
Substitutes: 12. Kim Grant 14. Alan Pardew. Alan Curbishley *(Joint Manager)*

Limited edition print of 181 copies, the total of competitive home matches played while in exile from the Valley 1985 - 1992

A limited edition print produced to record the day Charlton Athletic came home. Limited to 181 copies, the number of competitive home matches Charlton had played away from The Valley, a copy was presented to the manager, and each of those Charlton players involved on the day. Pictured are: Bob Bolder, Darren Pitcher, Scott Minto, Steve Gritt, Simon Webster, John Robinson, Lee Power, Carl Leaburn, Garry Nelson, Colin Walsh, Kim Grant, Alan Pardew and Alan Curbishley.

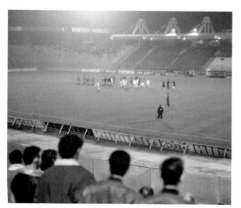

Above left: Charlton play in Europe – Stadio Del Comero, 9 November 1993. In the Anglo-Italian Cup, Charlton reached the latter stages of the competition to play Bresia and Ancona away, before taking on Ascoli and Pisa at The Valley.

Above right: The author (left) and a fellow Charlton supporter, Mick Norris. On the night Carl Leaburn scored Charlton's first and (to date) only competitive goal in an official European Cup tournament, in the 1-1 draw with Ancona.

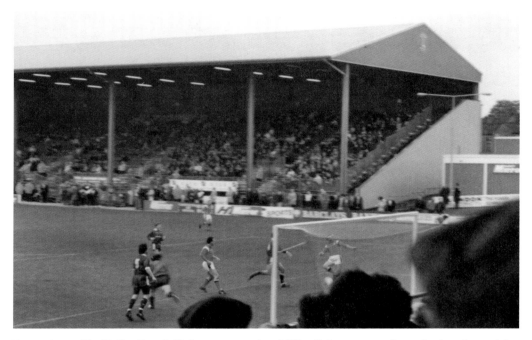

Returning to The Valley, Derek Hales scores against Millwall, in a veterans' match played on 9 May 1993. The 'temporary' West Stand, in the background, which had been erected for Charlton's return in 1992, would not be replaced until 1998, after Charlton were promoted to the Premiership.

A day at the Charlton Athletic training ground in New Eltham, south-east London. Manager Alan Curbishley is pictured working with Mark Bright, Steve Jones and Mark Kinsella in the 1996/97 season. Before the club returned to The Valley, new members of the board Roger Alwen and Mike Norris acquired the training ground in 1987 for £500,000, Charlton's first move to re-establish a presence in the borough. The facility included changing rooms, a weight and training room, a medical room, a kit room, a manager's office and several pitches.

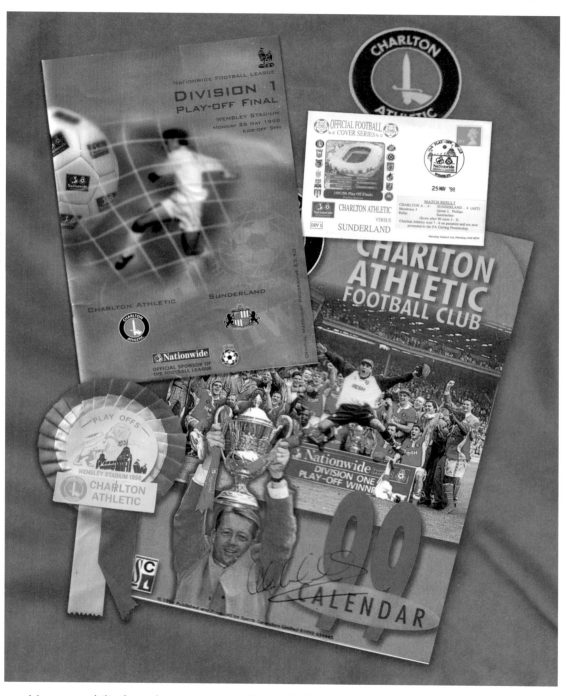

My memorabilia from the most memorable match I have ever witnessed since first supporting Charlton Athletic, the 1998 play-off final at Wembley, where Charlton Athletic won promotion to the Premiership, beating Sunderland 7-6 on penalties, after the match finished 4-4 at the end of extra time.

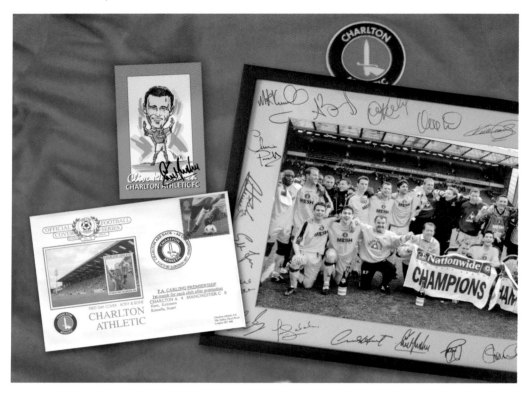

Above: Although only spending one season in the Premiership, Charlton Athletic returned in style at the end of the 1999/2000 season, and were promoted as First Division champions after a 1-1 draw away at Blackburn Rovers. In the first match of the following season, Charlton beat promoted rivals Manchester City 4-0 at The Valley.

Left: A champions trophy on display at The Valley. The title winners of the First Division were awarded the same classic trophy, designed and manufactured by Vaughton's of Birmingham, introduced for the 1889/90 Football League season, and won ever since by the old First Division champions, prior to the formation of the Premiership in 1992.

Charlton defender Steve Brown up against Ryan Giggs at Old Trafford on 12 March 1994, Charlton's first FA Cup quarter-final since 1947. Although losing the match 3-1, Charlton supporters on the day, whose numbers totalled over 10,000, had their first experience of playing up against the best team in the Premiership, Manchester United, who would go on to win the FA Cup and the title.

Three Charlton Athletic Premiership stars, Jonatan Johansson, Mathias Svensson and Matt Holland, all internationally capped players. Charlton were now in the big League, bringing in the type of player that supporters, at one time, could only ever have dreamed of. In the 2003/04 first-team squad of twenty-six players, eighteen had been capped for their country at under-21 and senior level.

With Charlton now well established as a Premiership club during the 2004/05 season, celebrations were underway to commemorate the club's centenary. A limited edition print was produced featuring five Charlton Athletic club badges, used through 100 years of the club's illustrious history.

Charlton Athletic line up to greet visitors Arsenal on Boxing Day 2005. From left to right: Charlton players Bartlett, Sorondo, Holland, Fortune, Hreidarsson, Kishishev, Hughes, Murphy, Bent, Myhre (shaking hands with Henry), Young (out of picture shaking hands with Lehmann). The gate of 27,111 would be the highest at The Valley during the season.

On 24 September 2004, the Charlton Athletic Former Players Association held a centenary dinner at The Valley for the past players who had served the club so well, through the good times and bad. In the photograph, Dickie Davies interviews Charlton's 'Sailor' Brown, one of many former players to feature in the centenary dinner, shown on Sky Sports.

The England team with Charlton defender Chris Powell, middle row third from left, 2001. The popular left-back made five appearances for the national side under manager Sven-Göran Eriksson, the first Charlton Athletic player to be capped by England since Mike Bailey thirty-seven years before.

Right: Alan Curbishley, on The Valley pitch during a press conference after being promoted as First Division champions in 2000. Curbishley had become the most successful Charlton Athletic manager since the days of the great Jimmy Seed, guiding the club through six successful seasons in the Premiership.

Below: Former Addicks John Robinson and Paul Williams turn out for a Former Players' Association match at The Valley during 2008, one of many games played for charity by the Charlton Athletic veteran teams, which have taken them to all parts of the country and overseas to Spain, Greece and Hong Kong.

Chris Powell, current manager of Charlton Athletic, and Jason Euell, in his second period with the club during the 2011/12 season. After appointing four managers in five seasons, a new board of directors made the bold decision to give the former Charlton and England international full-back, working as a coach at Leicester, his first managerial opportunity with Charlton Athletic in January 2011.

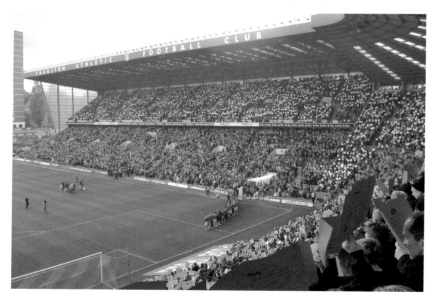

A big day out at a jubilant Valley, 5 May 2012. First Division champions Charlton Athletic take on Hartlepool United in front of an almost capacity crowd of 26,749. The Addicks had previously won the title in a 2-1 win over Wycombe Wanderers at The Valley on 21 April 2012. However, the celebrations and presentation of the trophy took place on the last game of the season, with Charlton winning the match 3-2.

The top table at the Player of the Year awards held at The Valley the day after they were presented with the First Division Champions Trophy. From left to right, behind the trophy: Erol Umut (head physiotherapist), Dr John Fraser (first-team doctor), Damian Matthews (first-team coach), Alex Dyer (assistant manager), Chris Powell (manager), Keith Peacock (football advisor).

First Division champions Charlton Athletic memorabilia from a season to remember: a signed flag and football, the first and last home programmes of the season, and a signed picture of the team promoted at Carlisle United on 14 April 2012.

8

RETURNING TO THE BEGINNING?

So here we are, back where we started, Charlton sitting above mid-table of the second tier of the Football League, with my Charlton supporting friends and family discussing the chances of promotion to the Premier League – very similar to discussions we had in the 1970s, when none believed Charlton had any hope of ever playing in the top division.

However, for supporters today, we know that promotion is not such an unrealistic expectation, as long as the board of directors do not break the bank attempting to do so. There is no doubt that gaining promotion into the Premier League will bring any club rich rewards, even if they are then soon relegated, as they will continue to receive a huge income through parachute payments to assist the club in adjusting to life in the Championship, and to pay players their Premier League wages, for a couple of seasons at least.

Running a professional football company, in today's Football League, is a precarious business, for business is now what it is. Compared to the days when clubs were run by the local butcher, baker and candlestick maker (or fishmonger in Charlton's case), directors and owners now come from all parts of the world and are involved in all types of international conglomerate businesses and corporations, with assets deposited in offshore tropical island bank accounts.

This new brand of directors and owners of clubs such as Charlton Athletic must ensure that the clubs they are custodians of continue to survive for the supporters and communities where they evolved, and not risk the existence of the club in chasing the dream of playing Premier League football. There can only ever be twenty teams in the Premier League – perhaps less in the future – and not every club will deserve to join this elite band, no matter how much money has been invested in the club through directors' personal fortunes, huge loans or undisclosed owner investments, all of which may eventually leave those clubs facing an unrecoverable debt.

Up the reds!

Above: Watching out from The Valley, the statue of 'keeper Sam Bartram, erected in memory of the Charlton Athletic's greatest-ever player.

Right: Charlton's Yann Kermorgant challenges for an incoming ball, in a 4-1 win over Bristol City in Charlton's last match of the season, 5 March 2013. Although home form had been indifferent for a majority of the season, Charlton's excellent away form, which included a 6-0 win over Barnsley, eventually kept them safe from relegation, where more than fifty-four points were needed to stay up.

Left: Charlton Athletic supporters celebrate a win at The Valley. After an eight-match unbeaten run at the end of the season. The in-form Addicks narrowly missed out on a play-off place by just four points, finishing in ninth place. With very little money available to spend in the transfer market during the season, manager Chris Powell and his team achieved more than any Addicks supporter could have reasonably hoped for, or expected.

Below: Happy fans leaving the ground at the end of a successful campaign back in the Championship, 2012/13 season, where the ultimate goal was first survival and then consolidation.